STREET FASHION PHOTOGRAPHY

TAKING STYLISH PICTURES ON THE CONCRETE RUNWAY

Dyanna Dawson and J.T. Tran

CHRONICLE BOOKS

SAN FRANCISCO

Library of Congress Cataloging-in-Publication Data available.

ISBN: 978-1-4521-1537-5

Manufactured in China

Designed by River Jukes-Hudson

10 9 8 7 6 5 4 3 2 1

Chronicle Books LLC
680 Second Street
San Francisco, California 94107

www.chroniclebooks.com

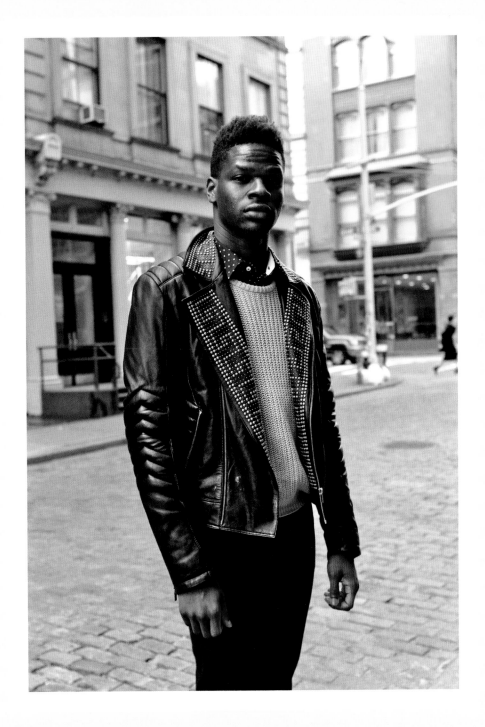

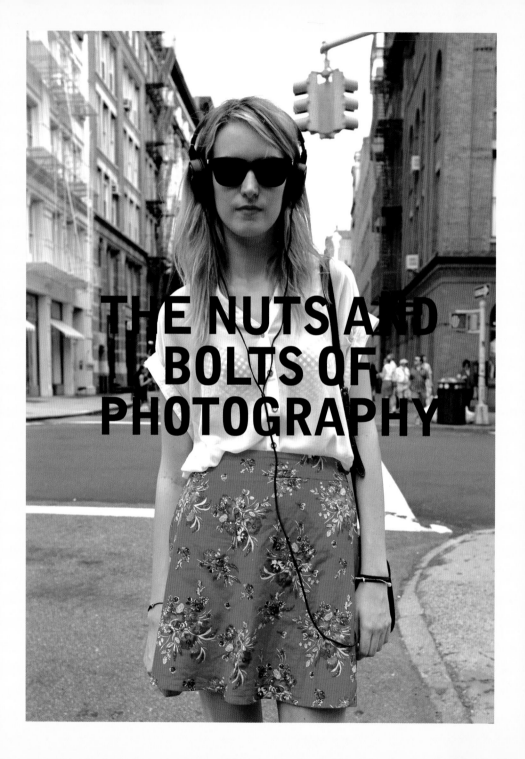

THE NUTS AND BOLTS OF PHOTOGRAPHY

Street style photography is an enjoyable and rewarding field. All it takes is a camera and some motivation. If you absorb the knowledge in this book and apply it well, you'll be taking stunning photos before you know it. Let's get started, shall we?

CAMERAS

So we've established that you will need a camera. To help you figure out which camera is best for you, we're going to break it down to basics. There are countless brands and varieties on the market, in addition to a plethora of camera lenses, flash units, and other accessories. With so many options, selecting the right camera at the right price point for you can feel overwhelming. Don't worry, we've got it covered. (If you want even more detail, cnet.com is an excellent source of information.)

Think about what you are able and willing to carry on your person every day. An important part of being a street style photographer is being able to capture the subjects around you at a moment's notice—especially if you plan to take candid shots. You've got to have a camera with you at all times, because you never know when you'll cross paths with someone fabulous. Understandably, larger cameras with multiple lenses are rather

burdensome and inhibiting to carry with you at all times, so you may want to find a compromise. Fortunately, technology is advancing rapidly, and there are many smaller, lightweight cameras that produce excellent results.

There are several things for you to consider when you are selecting a camera, including price range, purpose, and size.

1. Price range. How much would you like to spend on the camera? This will determine which cameras are available to you. It is not necessary to spend an enormous amount on your first camera, but you should keep in mind that the price of a camera and equipment often dictates its level of quality components and design. As the saying goes: You get what you pay for.

2. Purpose. You're going to be using your camera for street style photography, obviously! Thinking about how you'll use it will narrow down your choices. Where do you plan to go? Will you be photographing during the day or at night or both? Will you be in crowded areas? Do you intend to use the camera for other purposes as well?

3. Size. "The best camera is the one you have with you." Street style photography will require you to lug the camera around with you as much as possible, and for long hours. A heavy or cumbersome camera and accessories may not be the best choice to carry on your person all day, every day.

Skinny jeans have enjoyed enormous popularity in the last decade or so, making a lady in wide-leg trousers or bell-bottoms a beautiful rarity.

Of these three considerations, the very first question to ask your-self is "What is my price range?" Cameras and photography equipment can be very expensive, so once you determine the amount you are willing to initially invest, you can start to research options in your price range. We'll explore the different options in this section.

Category 1–Point and Shoot

In the **$100 and under** bracket, you will likely be limited to point-and-shoot compact cameras. Point-and-shoot cameras are the starting point and what most people seem to have already. They are affordable, light and compact, and easy to use. A few of the more expensive models can produce some surprisingly high-quality images. Even if you are willing to invest a lot of money in a high-end "prosumer" camera—perhaps you should learn to drive a Camry before you roll off the lot in a Ferrari. One word of warn-ing about point-and-shoot cameras is that technology is advanc-ing faster and faster, and the gap between cell phone cameras and point-and-shoot cameras narrows every day. Like any elec-tronics, the lowest priced items are usually the older models and thus the first to become obsolete.

These are very similar to what you probably already have on your cell phone, but include advanced features and a marked increase in image quality. They are named for their ease of use; one simply points the camera and presses the shutter button. This is the type of camera with which we started our own blog, theSFStyle.com. There's nothing wrong with these cameras. They will limit overall photo quality and the lighting situations you will be able to photograph in, but if you're just starting out, these cameras force you to develop your skills. After you've gotten used to composing a good shot and spotting the right time and place

There was a lot of foot traffic and actual car traffic in this photo, which was easily cropped out in post production. That's why it is important to stand back far enough to have room to crop your photo down if needed.

for decent lighting, you can upgrade your camera. Even if you eventually opt for a better camera, a small pocket variety can still be useful to have handy at all times and for situations where you might not want to bring along a cumbersome and expensive piece of equipment (such as a rowdy night out at a club or bar).

You might find yourself inclined to use your cell phone's onboard camera as an alternative at times when you're caught without your street style camera. (Hey, we understand; we've been there too.) You'll kick yourself later if you don't take the picture, and a cell phone camera is usually better than no camera at all. If you do plan to use your camera phone in a pinch, we recommend using a device that has at least a 5 megapixel resolution and be sure to temper your expectations on image quality. Cell phone cameras are best used "only in an emergency."

In the **$200 to $500** range, you will be able to get a higher quality point-and-shoot. We consider this to be a waste of money considering what you can get for just a little bit more.

Which leads us to the next tier . . .

Category 2—Micro four-thirds

Micro four-thirds cameras are in between full-fledged dSLRs and point-and-shoots. Technology is heading in this direction, making cameras smaller and lighter, while allowing them to use the interchangeable lenses and high-end sensors of dSLRs. Micro four-thirds cameras get their name from their 4:3 aspect ratio. What that means to you is that the images from theses cameras will be more of a boxy square shape than those from other cameras that have a 3:2 aspect ratio and produce the rectangular shape you're probably familiar with. The aspect ratio is not a major issue for street style photography, because you can crop images to any format you wish during the editing process. Micro

four-thirds cameras are relatively new and will be changing rapidly compared to point-and-shoot compact cameras and dSLRs. This doesn't mean that you shouldn't consider one—some of the photos in this book were taken using this type of camera. Its manageable size makes it easy to carry in your bag every day, and it gives you the best quality possible in its price range.

Category 3 — dSLR

In the **$500 to $2,300** price range, you begin to find the crop-sensor dSLR (aka Advanced Photo System type C or APS-C format for short). The acronym "dSLR" stands for digital single lens reflex. (The word *reflex* here is misleading, because it actually refers to the reflected image through the camera's mirror prism, not a reflex action.) This kind of camera can be used with different lenses, giving you different results when shooting in specific conditions. Being able to swap out lenses is definitely useful, but the main reason to upgrade to a dSLR camera is the increase in image quality. A camera of this grade coupled with an appropriate lens will give you a dramatic increase in the resolution of your photos, the color and contrast, and also the lighting conditions that you can reasonably shoot under. These are the reasons it might be worth it to avoid the $200 to $500 range and save up for a more expensive camera—a $600 dSLR has a great quality-to-price ratio.

Most professional photographers use dSLR (digital single lens reflex) cameras. Because these cameras use an internal mirror to reflect light onto the sensor within the camera body, they cannot be made as small as the compacts and micro four-thirds format cameras. They are the most versatile cameras, though, since you can switch lenses. They also produce the highest quality photos, since their larger size affords them a larger sensor that

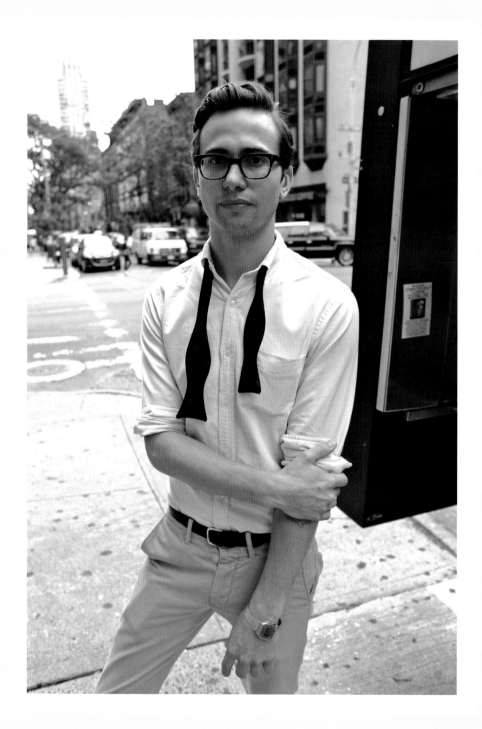

registers more light and more detail and at higher resolutions. The downside, of course, is their cost. The camera bodies are expensive, and lenses are purchased separately. High-end, full-frame dSLRs cost thousands of dollars. There are dSLRs with smaller sensors (APS-C format), however, and these cameras generally start at between $500 and $600. Digital camera prices have been steady in the last few years, since the technology has reached a plateau. Until the next major leap in technology, it is unlikely that the cost of dSLRs will fluctuate wildly. (Camera lenses for popular formats and brands retain their value even more, since they are usually still compatible to the newest models of camera body—the lens format hasn't changed in decades.)

The **over $2,300** price range is the cream of the crop for what you're going to need. In this bracket, you can afford a full-frame camera. *Full-frame* means that the large chip inside the camera that captures images covers a field of view equal to that of a classic film camera. So with the same lens and standing at the same spot, you'll get a much wider field of view on a full-frame camera than on other digital cameras (appropriately called crop-sensors because the field of view is "cropped down" and smaller). The wider field of view is useful for street style fashion photography, since you will probably end up in some crowded situations where you can't really back up very far from your subject. With a wide-angle lens on a full-frame camera, you can photograph your subject from head to toe standing only five feet or so away. The other very important advantages in this price range are a considerable

This man was spotted in Manhattan's Upper East Side. We really liked his undone bowtie, which showed that he was either on his way to or from work. This is one of those instances where it really pays to have a camera on you at all times—even if you're just out running errands in your own neighborhood.

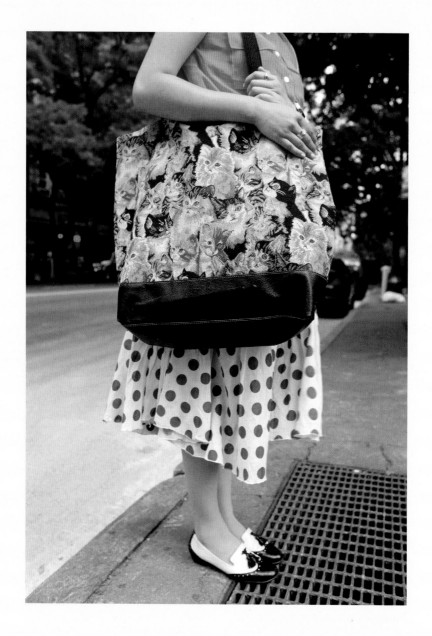

The bright color, interesting bag, polka dots, and shoes are not only intriguing fashion pieces, but surefire bonuses toward getting a vibrant and stunning photo. Beautiful color and texture are good elements to have in any photo, especially for street style.

jump in resolution, true colors, and excellent image quality under a wider array of lighting conditions. You'll discover that a high-end camera will give you better results in less than ideal light conditions.

Anything more advanced than a dSLR (such as a medium-format camera) costs more than $20,000 and is more than you need for the purposes of street style photography. We advise starting to think about camera choice by selecting a price range and then thinking about features. Our next section will give you some things to consider when narrowing your choice.

Features to Consider

Canon and Nikon are like the Coke and Pepsi of the camera world, the two heavy-hitter brands. A few alternative brands get a smaller share of the market. The quality of the different models varies, so it's wise to do some comparison shopping and read consumer reviews on Web sites like cnet.com and amazon.com. Buying Canon or Nikon is usually a safe bet in terms of quality, but value is another story. There's also the issue of holiday sales and such. A little market research can go a long way. All of the photos you'll see in this book were shot using either a Canon dSLR or an Olympus four-thirds.

The brand of camera body you select will be especially important if you plan to purchase a dSLR. Remember that camera equipment is generally proprietary. If you buy a Canon camera, you'll have to rely on Canon brand lenses, flashes, and other accessories. A few third-party manufacturers offer compatible equipment and accessories, but you are pretty much restricted to what is made for your brand of camera. Whether you select Canon, Nikon, Olympus, or Sony, make sure that the brand you

choose offers the variety and quality of lenses and accessories to suit your needs down the road. You'll want a camera you can grow into. Once you've committed to one brand of camera body, it can be costly to switch brands.

Megapixels and Capabilities

Don't assume that more megapixels necessarily mean better photos. These days, even the cameras on an average smartphone have 3 to 5 megapixels, which is enough for a low-resolution Web photo. A standard dSLR has around 12 megapixels and a "prosumer" model with a full-frame chip will have 20-plus megapixels. More megapixels simply mean more pixels in the photo, and thus more detail when you zoom in—which allows you to reproduce the photo at larger sizes. Consider the medium you plan to use to display your photos. Higher resolution will be necessary for print, but not Web. If your goal is to start a blog, you do not need to have a high-end camera right away, since you can get away with lower resolution for photos posted on the Web. The issue of megapixels will only come into play if and when your work is published in a paper format, such as a magazine or book. Like this one. Baby steps, though—as we warned you earlier—it might not be the best idea to buy an expensive sports car for your first set of wheels.

LENSES

Ahh, the meat to the potatoes. A camera is only as good as the "glass" you put on it. (That's how the cool kids refer to their lenses.) Seriously speaking though, lenses are very important. If you do purchase a dSLR, remember that a good lens or two is an important part of the initial investment. Some dSLRs come

packaged with a kit lens, but these lenses are usually of poor quality. It's best to buy the camera "body only" and customize it with a good lens of your choosing.

IMPORTANT LENS TIP: When you are attaching or detaching a lens, make sure you align the red dot on the lens with the red dot on the camera. Those dots are there to help you. Lenses can jam if installed improperly. Also, keep the contacts—the metal rings on the inside of the lens and the inside of the camera where they connect—clean and unscratched. These metal parts transmit data between the camera and lens. Last but not least, don't switch lenses in dirty or unstable places. The insides of your camera and lens will be exposed, and dust or dirt that gets in could damage your equipment.

So what lens should you get? Well, for the purpose of street style fashion photography (SSFP), you will likely be shooting people right in front of you, and perhaps as far back as ten to fifteen feet at the most. To capture this close-range action, we think that shooting with wider angle lenses is most effective—20mm to 35mm on most cameras. However, if you want to use your camera for other purposes too, you may want to get a versatile zoom lens that covers many ranges.

Prime Versus Zoom. Many photographers insist that prime lenses (lenses that do NOT zoom) produce better quality photos. We subscribe to that school of thought. There is a simplicity to prime lenses, since your only concern is focusing. If you need to fit more into the frame, you can take a few steps back. Primes are also smaller and easier to carry. So for the purposes of street style photography, we recommend prime lenses. Zooms do have the advantage of being able to zoom in when you are in a situation where you can't get closer to your subject, like a crowded wedding, concert, or fashion show, but if you plan to focus exclusively on street style, you won't necessarily need a zoom.

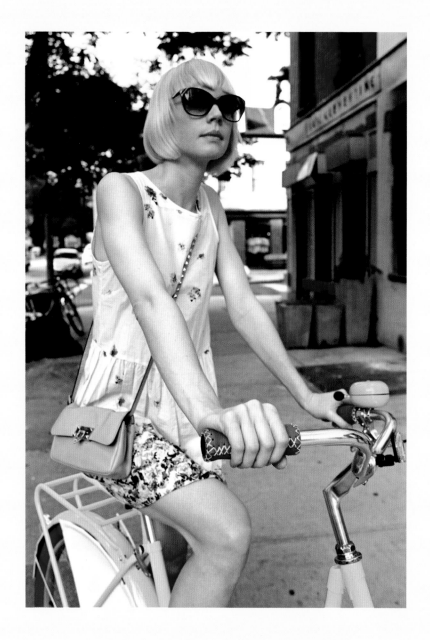

Sometimes a girl's best accessory is her bike, and that's
exactly why we chose to stop this subject. Plus, it doesn't hurt that this is
Erin Fetherston, noted fashion designer.

Lens Designations 101

Cameras have developed something called the 35mm standard, which is a carryover from the days of film photography. Full-frame dSLRs capture the same range as the 35mm standard, so lens designations are set to this range. Using a given lens with a crop-sensor dSLR will capture a smaller field of view than it will with the full-frame dSLR.

In the world of camera lenses, the focal length is measured in millimeters, so you will see lenses designated as 20mm, 50mm, 350mm, and so on. The number indicates the distance between the glass lens and the sensor. The smaller the number, the wider the field of view the lens will capture. So if you stand about five feet from a person of average height and hold your full-frame dSLR vertically with a 20mm lens, you will be able to photograph the person from head to toe. If you have a 50mm lens, you might be able to fit only the upper part of their body in the frame unless you step back a bit.

The other reference number related to lenses is the maximum aperture, and this is measured in Focal numbers (commonly known as F-stops). The aperture is the mechanism inside the lens that allows less or more light into the camera sensor. (Common F-Stops you might see on lenses are f/1.2, f/1.4, f/1.8, f/2.0, f/2.8, f/4.0, f/5.6, and f/8.0.) The lower the number, the wider the maximum aperture the lens has. This means that the lens can let in more light when the camera shutter opens and closes, and thus capture the image more quickly. Faster shooting is important for street style photography, because you will probably not use a tripod as you comb the streets for fashionable subjects. The faster the lens and camera take the picture, the less time

L: If you are shooting an oversized item, make sure the photo really displays how big the item is in comparison with the person.

R: Sometimes size **DOES** matter.

L: We stopped this lovely lady for two reasons: her beautiful curly faux-hawk and her jaunty high-waist shorts. By getting in closer and angling her body 45 degrees we were able to capture the best of both elements in one frame—rather than splitting it into two different photos.

R: Remember that less is more, and not every outfit you choose to photograph has to be elaborate and intricate. You'll find this to be very useful for the hot days when most people simplify their outfits to just one or two layers.

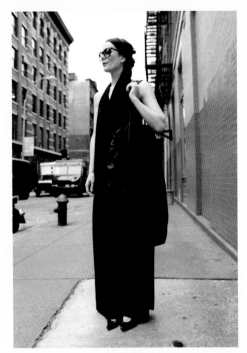
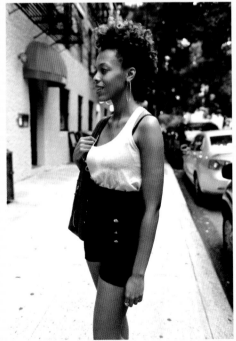
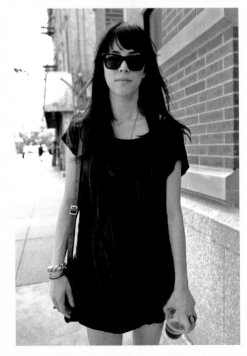

We shot this stylish man during the fall and again during the winter.
If someone is truly fabulous, why not photograph them more than once? Especially
if their look changes or evolves with the seasons.

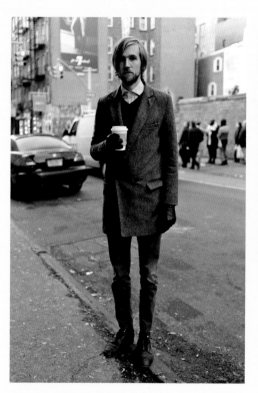 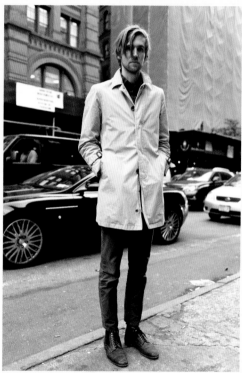

We made good use of bokeh and color contrast on this shot. The black outfit and
red lipstick really stand out here. To achieve this, try using a dSLR with a normal to
wide-angle lens that has a fast maximum aperture. This shot was taken
with a 28mm f/1.8 lens on a full-frame camera, about four feet away from the subject.

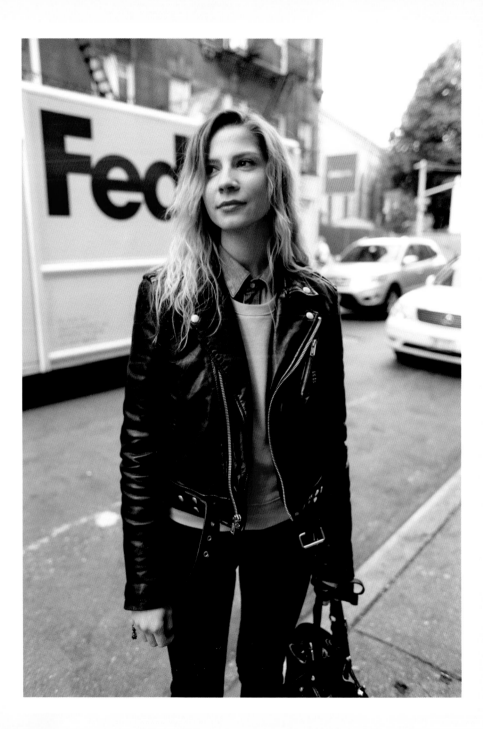

there is for the slight vibrations in your hand to blur your shot, and the sharper the final image will be.

When you shop for lenses, you'll see them designated with the two main reference numbers (for example: Canon EF 50mm f/1.8, which happens to be a classic lens that many photographers use for taking portraits. There are faster versions of this lens, too— Canon EF 50mm f/1.4 and Canon EF 50mm f/1.2). Other companies make basically the same lens for their own camera models (for example, Nikon 50mm f/1.8). Remember that lenses are rarely compatible with different camera brands. You'll also see lenses with even more numbers, like Canon EF-S 18-55mm f/3.5–5.6 IS. That means the lens is a zoom, and the numbers indicate the zoom range.

The letters in the lens names are format designations for the camera body types they can be used with. Contemporary Canon dSLRs use the EF-type mount, so EF lenses can be used on them. EF-S lenses can be used only on crop-sensor Canon dSLRs, and are thus usually less expensive than straight EF lenses. Every camera manufacturer has its own proprietary format designations, the same way every car company has a different way of naming its various models. A good online resource for information about lens compatibility is good old Wikipedia:

http://en.wikipedia.org/wiki/Category:Lens_mounts

The letter designations IS and VR stand for Image Stabilization and Vibration Reduction. Some lenses have this capability, and some cameras have it as well. It can be useful, but after you practice and get good enough, you won't really need this feature in order to take sharp photos.

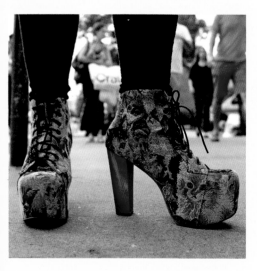
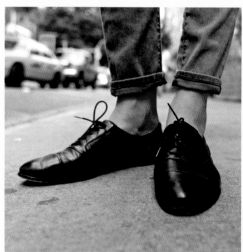

Sometimes people have standout pieces, like a pair of eye-catching shoes or an ostentatious bag. Make sure to take some close-ups of those pieces, and remember to get down to their level. This ground-level perspective shows the location with a nice background, and also captures the shape and print on the shoes.

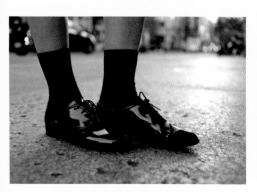
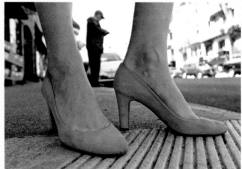

If you have a crop-sensor dSLR: The focal length we use on our crop-sensor dSLR is 17mm. This allows us to photograph a person head to toe from just a few feet away. However, a lens this wide will cause a little distortion on the far sides of your frame. At 17mm, the distortion is at a manageable level, but a wider angle lens may give you unacceptable distortion. If you prefer less or no distortion, you will have to use a lens in the 20mm to 35mm range. Once you get past 35mm though, you'll have to back up pretty far to fit a person in the frame from head to toe, and that could be a problem in a crowded location or narrow street.

If you have a full-frame dSLR: The same rules apply, but we would bump the focal length up to the 24mm to 50mm range.

HERE'S A HELPFUL TIP: To figure out the lens equivalence between a crop-sensor and a full-frame camera, you can do a little math. Crop-sensor dSLRs are also known as "1.5 cameras" because the smaller sensor diminishes the field of view by roughly 1.5 times compared to a full-frame sensor. So, on a crop-sensor camera, a 35mm lens will capture the narrow field of view that a 52mm will capture on the full-frame (35 x 1.5). To convert the other way, just divide rather than multiply.

Hoods and Filters

Both lens filters and hoods protect your camera lens from physical damage and improve your photo quality. Neither is absolutely necessary, and we don't use them for our own work. Don't let that stop you, though.

Hoods. Hoods are usually made of a hard plastic resin, and they often come with the lens. You can also buy them separately. The hood typically attaches with a simple twist on the end of the lens,

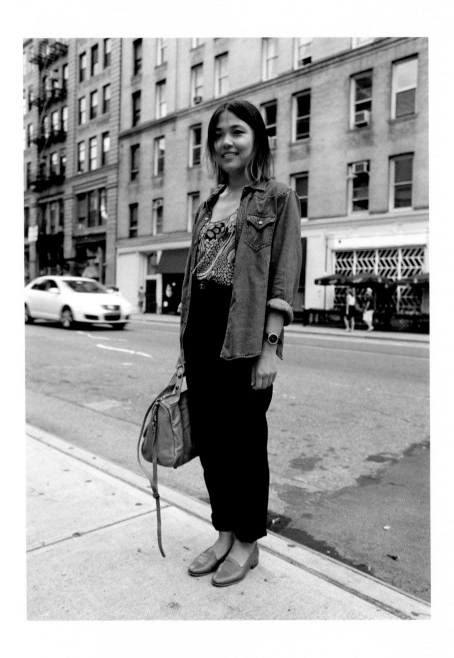

A lower angle was used for this shot to help elongate this classy petite young lady.

shading the camera lens from excess light and minimizing hard shadows and glare. The hood also protrudes, protecting your lens somewhat from physical impact. Hoods do add a bit of bulk, and from personal experience, we can tell you that leaving the hood on and putting the whole camera in your bag is not a good idea—the plastic hood could snap. Some hoods prevent you from replacing the camera lens cover, and you ALWAYS want to put the cover back on when the lens is not in use. Scratches on a lens can show up in the images taken with it—reducing its usefulness and value dramatically.

Filters. There are many kinds of filters. Some colored filters are used to tint photos artistically. We don't recommend these, because it is easy enough to tint photos in the post-production editing process and having photos with their natural color and light gives you the option of leaving them as is or tinting. Some filters protect your camera from ultraviolet light and polarize the light in an optimal way. They also serve as a protective layer for the surface of your camera lens. We don't see anything wrong with this kind of filter, but it is not necessary for you to use one to take great photos, so the choice is yours. Do make sure to get the proper size if you decide to use a filter. Not every lens has its filter thread size listed on it. If you can't find it, just ask for help at a store that sells filters or look up your specific lens online.

EXTERNAL FLASH UNITS

We could fill a second book with information about flash photography, because it is an almost entirely different beast than photography with natural lighting. Street style photography will

rarely—if ever—require a flash, so we are only going to touch on the basics. Use flash only when you have no other choice. Street style photos look best with ambient light. Flash units introduce even more challenging variables to your task.

Most point-and-shoot compact cameras have an onboard flash, as do crop-sensor dSLRS. Even cameras that are built into cell phones sometimes have a flash. Don't use the flash unless you have to. We have three good reasons. First, a photo that is possible to take with available light almost always looks better without flash. Second, flash can cause a lot of unwanted results, like red eyes, flash reflections off of glasses and shiny materials, and, of course, people blinking or reacting uncomfortably to the flash. Third and last, most onboard flash units are not of sufficient power and quality to get the job done.

So when should you use flash? When you can't get the photo any other way. You might be in a dark indoor area or photographing at night. By all means, something is better than nothing. If you plan to do a lot of photography in dark situations or candid shots of people indoors, a flash will be necessary, especially to capture the shot sharply when people are moving. Invest in a dSLR and get a compatible external flash unit. These units range in price from $100 to more than $1000, but a perfectly acceptable unit should run you about $100 to $300.

As with every other type of camera equipment there are many different ways to identify flash units, and there is no universal system. Do some online research. Some features that we highly recommend are:

—An adjustable light that can swivel up and down and side to side. You can experiment with bouncing the light from the flash

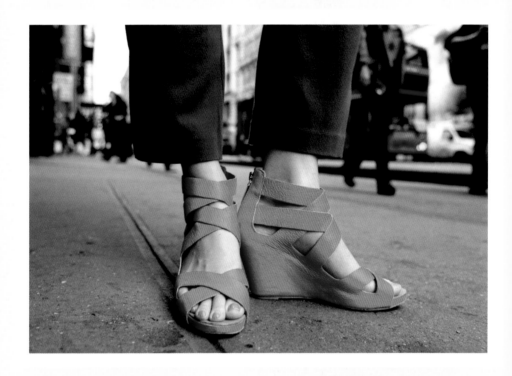

Bright color is one of the most common things photographers look for
in a shot. Again, the ground-level view shows the street and background of this loca-
tion, making the shot more interesting. These low-level shots aren't that hard
to do; just practice kneeling and holding the camera a few inches off the ground.
Obviously, you can't really look through the viewfinder, so it may take a few tries
to frame the shot accurately. Remember: Practice makes perfect!

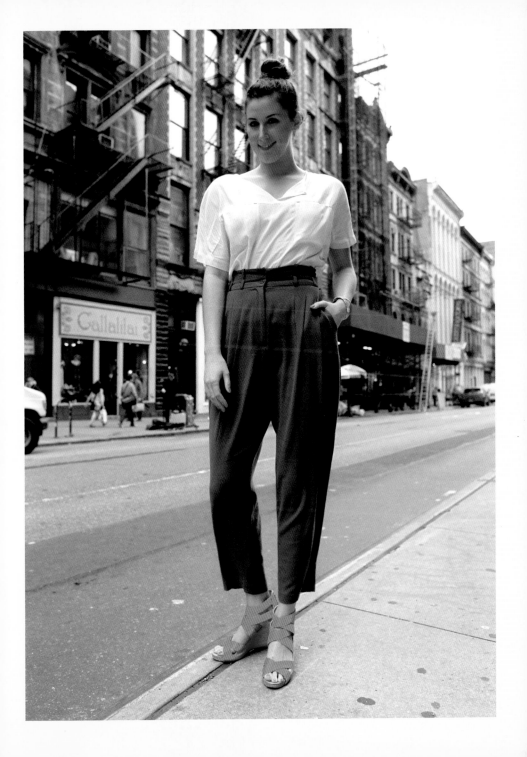

off a wall or ceiling. This isn't something you will do often, but the option is nice, and this feature will give you the room to grow and learn more.

—As fast a recycle time as possible. Flash units use a lot of power, and it takes time for them to build up a charge so you can take another shot. Better units charge faster, so you can take shots more quickly. Flash photography is often used to capture people candidly as they move, so the faster your camera is ready to shoot the better off you'll be.

—Good TTL (through the lens metering). This is one of the most important aspects of the flash unit, because it will be hunting in the darkness for the proper spot to focus on, and the better the flash is at doing it, the more of your shots will be in focus.

—Overall power. A flash should be strong enough to illuminate your subject in the frame. Most flash units that cost around $100 should have no problem with this.

—A diffuser. Many external flashes have a white plastic lip that you can pull out and use to cover the lighted portion. This lip diffuses and softens the light, minimizing overexposure when photograph-ing people. We also suggest using an additional diffuser. These are usually very inexpensive and snap right on. Using a flash without anything to soften the light will give you very harsh results.

Taking Photos with Flash

Here's the good news: Flash photography can be really fun and is more about quantity than quality. You won't often be able to

compose the image through the viewfinder, or compose the image much at all. It will be too dark for your eye to see. That's what the flash is for. You just want to point the camera in the right direction and take as many shots as you can. This introduces a whole new dynamic into your photography, and you'll get a bit more of an organic and random look to your compositions. This doesn't mean you shouldn't try to compose the shots or take your time. Just be aware that the situation will be very different, especially if you're photographing people candidly.

There's another bonus. Since you won't always be composing through the viewfinder, this is your chance to experiment with taking photos without holding the camera over your eye. Hold the camera above your head. Hold it low and point it up. You can shoot from angles you couldn't before. It will be a whole new learning experience, so just try to enjoy it. Also, you can now take many shots while people talk, move, dance, whatever. Just have fun with it.

Okay, now to the technical side:

—An external flash unit typically slips onto the top of the camera, locking into the metal square mounting bracket called the "hot-shoe." Make sure it is locked on. Also, make sure the metal contacts are clean and unscratched. They are transmitting data between the camera and the flash. You'll notice the additional heft the external flash puts on your camera. Hang on tight.

—Turn on the flash first, and make sure you have all the settings correct (consult the instructions). Then turn on your camera and set it to full-auto. You can use manual mode to shoot in bursts, but it's good to get comfortable with the flash in full-auto.

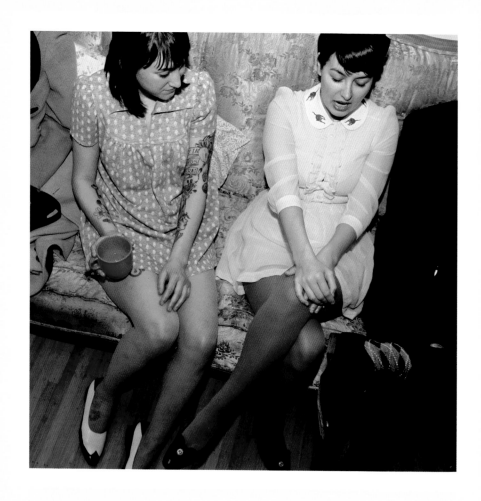

Here's a shot taken with flash. As you can tell, the subjects weren't truly posing. In fact, this was taken mid-conversation. Due to the flash, we were able to capture a moment and an angle that we would not typically have been able to capture.

—Now experiment with your flash before using it on a real shoot. Learn the range and the space that your flash will illuminate. Learn how long it takes to charge up, and thus, how rapidly you can shoot. Make sure it focuses on the right objects or people.

—Many external flashes fire off several mini-flashes before the main flash. These mini-flashes are used to find the target and focus accordingly. If you have the setting turned on, these flashes also dilate a subject's pupils, minimizing the red-eye effect that a flash often causes in the final photo. Get used to the timing, and bear this in mind, since many people confuse the first mini-flash with the actual moment the photo is taken.

—Last but not least, take photos with the camera held horizontally. For normal head-to-toe shots without a flash, you will want to turn the camera vertically to match the shape of an upright human body. You can't really do this with a flash. If you turn the camera on its side, the flash unit will be off to one side of the camera, and you will be illuminating one side of your subject, creating very odd lighting in the photo. There are ways around this, of course. You can photograph the subject standing near a wall and reflect the light off the wall, but for the most part, you shouldn't do this. It just doesn't work.

HOW TO HOLD A CAMERA

Like most skills, producing excellent street style photos takes some degree of knowledge, training, and a lot of practice. We say "produce" instead of "take" because anyone can click the shutter button to take a photo. Excellent photos are produced by

a photographer who has ability and experience to compose the perfect photograph. This is someone who also takes the time to edit the photo to produce a beautiful final image. Let's talk about how you can make this happen.

Have you ever used a hammer or cradled a baby? Holding an object sounds like a simple task, but for certain objects, there's a right way and a wrong way. With any camera, you have two main objectives: Keep the device secure and safe in your hands and keep the camera steady while the shutter takes the photo. Stability is important, because shaky cameras take blurry photos.

Use both hands when holding a camera, firmly gripping both sides equally. Be careful with folded lens ultra-compacts— their lenses are sometimes located in the upper left or right corner and can be blocked by your finger. If possible, hold the camera with elbows bent and locked, and with the viewfinder or view screen in front of your face. This will minimize shakiness. Smaller cameras have the advantage of being really light and easy to maneuver. Don't be afraid to try unconventional angles. Once you get used to this standard grip, try holding the camera higher or lower than eye level.

Larger cameras with big lenses—such as dSLRs—require a different grip. Hold the right side of the camera with your right hand and cradle the lens underneath with your left hand, being careful not to grasp the focusing ring on the lens if you're using auto-focus. (You don't want to accidentally adjust the focus and

We don't advocate smoking, but if you meet the subject during a moment like this, roll with it. It will remind the viewer in a subtle way that these are true street style photos, and these models are truly random people you stopped on the street. (Be careful about someone with a bunch of shopping bags though, because something so substantial can be too distracting.)

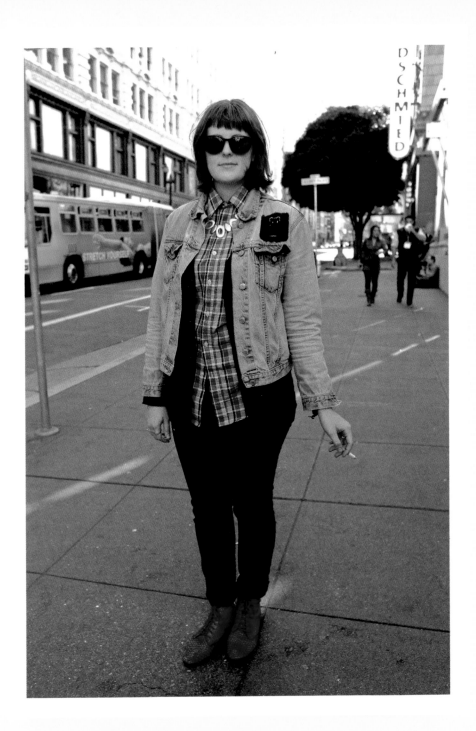

blur the photo.) If you are using a strap for your camera, you can have it loosely around your neck so it's not in your way. Again, you should bend and lock your elbows for stability. It is almost always preferable to use the viewfinder on dSLRs. That means that while you are taking a photo, your eye is stuck to the viewfinder. Consequently, taking photos at different angles means getting up on something higher like a chair or steps or bending down to get low. This is where the yogis among us have an advantage. You'll want to avoid shaky legs by locking your knees and bending at your hips or waist.

Techniques for Shooting Freehand

Street style photography is a spontaneous art form. You'll find that because of time and mobility constraints, you won't have the option of stabilizing the camera with a tripod. Even if you lug around a tripod, most strangers on the street will not have the time or patience to stand around while you set up the tripod and prepare the shot. So here are some extremely useful tips for taking photos freehand.

When you press the shutter, do it gently rather than jamming on it. Steady your breathing and lock your arms in a comfortable position. Military snipers and sharpshooters use these same techniques to steady themselves when they fire their weapons. Whenever you aim anything, be it crossbow or camera, the slightest movement changes the end result drastically, so try to steady yourself. You can also find a makeshift tripod if there is something to rest your camera on safely. If you have to become your own tripod, make sure you're as comfortable as possible. Stand in a secure position and try not to tense up, because tensing up actually causes your body to vibrate more. If you have to

lower the camera, try bending at the hips like you're bowing to someone. It looks silly, but it is far more stable than bending at the knees, which puts a lot of pressure on your muscles and can cause you to shake.

Turn on the burst setting on your camera. Not all entry-level cameras have this feature, but mid- to high-level cameras will have the ability to take continuous shots as fast as the camera and memory card will allow. This helps you obtain better photos in two ways: First, more shots taken mean more chances that you'll get the perfect photo. Subjects blink or fidget, pedestrians and cars appear in the background of busy locations, the sun peeks in and out behind fast-moving clouds—all of these factors affect the outcome. You will want as many options as possible when you select the optimal frame. Second, burst setting also increases your chances of getting a sharp photo. Even the steadiest hand can't help the slight movement of pressing the shutter button. Burst mode enables you to simply hold down the button while the camera fires off many rapid shots with less camera tremor, and thus, sharper images.

Focus: Manual versus Auto

The auto-focus feature on newer cameras will often be reliable, but there are some things to know. There's a diamond-shaped set of boxes when you look through a camera's viewfinder (especially dSLR cameras). The diamond-shaped boxes are essentially the targeting crosshairs of the camera. Those boxes help the camera's lens to identify what to focus on. If you want to focus on something but don't want it to be in the center of the shot, focus on the object and then press the shutter release halfway until you see the focus lock onto your desired spot. You can then

move your camera to compose the photo and depress the shutter completely.

Carrying the Camera (protection and accessibility)

We don't often use camera straps. It makes us look and feel like tourists and less like professionals—but most important, it gets in the way while we're working quickly on an impromptu street style shoot. While we prefer to go sans strap, we don't necessarily recommend going strapless with your own camera. There is certainly the potential for your camera to be stolen by a thief with fast hands or, more likely, you might simply drop your camera.

While camera safety is a common concern, for street style photographers accessibility is equally important. As your subjects bob and weave in and out of crowds, candid, street style opportunities can appear and disappear in the blink of an eye. The extra thirty seconds it takes to unbuckle your camera from its layers of casing can mean the difference between getting the shot and walking away disappointed. A good compromise is to have your camera in a sturdy tote bag, from which you can easily grab it at a moment's notice. The problem, of course, is so could a thief. Take care to be safe with your bag in crowded areas, and also be wary of bumping into walls and doors, since tote bags do not offer much protection against hard surfaces to your camera.

ELEMENTS OF A GOOD PHOTO

Beauty is in the eye of the beholder—everything visual is subjective. There are, however, consistent elements present in most

professional and aesthetically pleasing photos. We'll go over how these elements work specifically in a street style situation.

Light

Cameras require proper lighting to capture a good image. Not enough light, and the photo is dark and grainy. Too much light, and the photo is overexposed and washed out. Shooting in the shade can create a bluish hue to your photo, and shooting in partial shade frequently produces dappled and unusable images. Sunny days can give an orange tint, whereas indoor lighting is often insufficient and yellow. These are the challenges every photographer faces. Studio photographers have the ability to control the light in their setting and the time to experiment and optimize their camera's settings to the studio's light. Street style photography will not grant you either of those luxuries. Every camera and lens will give you different results in different situations. Only time and experience will help you master the art of selecting the best lighting scenario. Of course, settings on your camera are specifically designed to mitigate this. But ideally, you want to find a spot without too much harsh direct light and minimal cast shadows. Every camera is unique, and it's important to know the lighting capabilities of your particular model. It's a good idea to test your camera in various light situations and learn how much light is ideal before you start stopping potential subjects on the street.

"The golden hour" or "the magic hour" is the first or last hour of sunlight in the day, where the quality of the light gives a particularly warm and engaging effect. In the middle of the day, the bright overhead sun can cause overexposure and dark shadows. This harsh lighting is a major issue whenever you photograph people, because it is unflattering and makes the clothes and subject harder to see in the resulting photo.

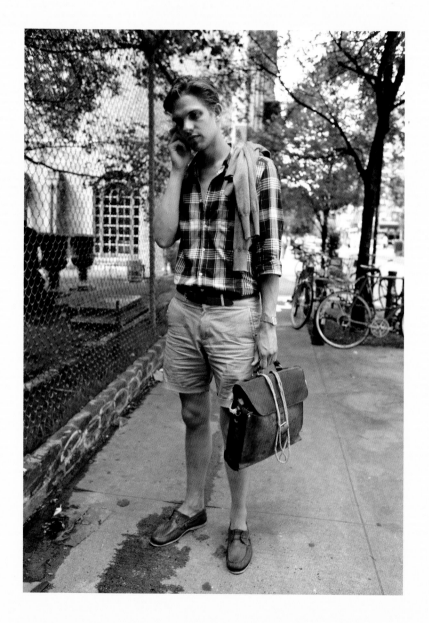

The leather on his bag is divine. You'll also notice that the subject is on his phone. You might encounter someone fabulous on their phone—and while we ourselves hate to rudely interrupt people, we have had luck tapping potential subjects on the shoulder and pointing to our camera as a quick way to ask permission for a photo.

During the golden hour shadows are less dark and high-lights are less likely to be overexposed. Most important, colors are true and will be more vibrant with brilliant contrast.

Composition

Hand-in-hand with proper lighting is your ability to place your subject and camera in the best spot to give you a well-composed photo. You can't control natural lighting, but you have almost complete control over composition. Again, practice and experience will improve your understanding of composition, but there are some very solid guidelines to consider when you take street style photos.

What IS composition? It is the placement of subjects and backgrounds. It's a simple idea, but there are infinite possibilities for where to place your model and camera. Don't be overwhelmed though; finding the perfect shot is part of the fun!

The good news about composing a street style photo is that you almost always want the subject in the center of the photo. That part is easy. But what to place in the background and from what angle to take the photo? Here are some important guidelines to help you.

Most of the time, try to have the subject stand without anything close to them in the background. Having them stand directly in front of a wall, hot dog stand, tree, car, or other people, for example, introduces factors that might detract from the composition. Also, the more space behind your subject, the better chance at creating bokeh (blur in the background), due to the depth of field. (We explain bokeh further in the next section.)

For a full-length shot (aka a head-to-toe shot), the subject should fill roughly two-thirds of the frame, with the remaining one-third as a space buffer on the sides, top, and bottom. Have about twice as much space above the head as below the feet. This spatial positioning will give you room to crop, since your subject may be off center in the photo. A photo with the subject's head and feet touching the edges looks cramped, poorly composed, and unprofessional. Besides, you want to have a bit of the background, since this is STREET style photography. The street is part of what makes it different from fashion photos shot in a studio setting. When you take any three-quarters shots, you'll generally want to shoot from the mid-thigh up, still leaving a little space over the head of the subject.

Get close to your subject to capture shoes, bags, and accessories. When photographing anything lower than you are, get down to its level. It's especially important to place the camera close to the ground for shoes. If you just aim the camera down the background of the shot is going to be the ground, and that rarely makes for an interesting composition. Again, this is street style, so include the urban backdrop when you can. Use it to make a pleasing frame for your composition. Part of what makes street style photography unique is the beautiful backdrops. Avoid backgrounds of blank walls or pavement.

A common adage in photography composition is: "If your photo isn't very good, GET CLOSER." This is a very useful thing to remember, because many amateur photographers think that what they see with their naked eye is what the camera will capture. You must always try to look through the view finder, or on your point-and-shoot's screen and consider only that. Just don't overdo it— in street style photos, you still need to try and show the outfit as a whole when possible. Make sure to take photos from many

different ranges and angles. Step forward. Step back. Step to the side. Walk to the opposite side of your subject and have him or her turn around.

Don't forget to focus. While framing the shot, remember to check that you focus on the person. You always want the person in focus. ALWAYS.

Sharpness and Bokeh

We've gone over how to shoot in order to get your subject in focus and sharp—but what about the background? Ideally, street style photos have blurred backgrounds to help the subject stand out. This effect is called bokeh, which arrived in photography from the Japanese. The effect is typically created by using a camera lens with a narrow depth of field. Certain lenses, when focused on a subject at a certain distance, will render the subject sharply in the photo while the background and foreground are blurred. Bokeh is not mandatory for a great street style photo, but it can be a very effective technique to have in your tool belt.

To understand bokeh, you must understand depth of field. This is the distance between the nearest and farthest objects in a photo that appear acceptably sharp in an image. Different lenses will have different depth of field ratios. This is why we recommend using dSLRs with fast, wide-angle prime lenses. Anything from 17mm to 50mm with a maximum aperture of f/2.8 to f/1.2 will most likely give you a narrow depth of field, and thus a lot of bokeh. Proximity to your subject also affects bokeh, and you will notice that the background will have more bokeh in a close-up shot. We do want to warn you that there can be too much bokeh. This occurs when the depth of field is very narrow, if, for example, you focus on the subject's eyes and the tip of their nose is out

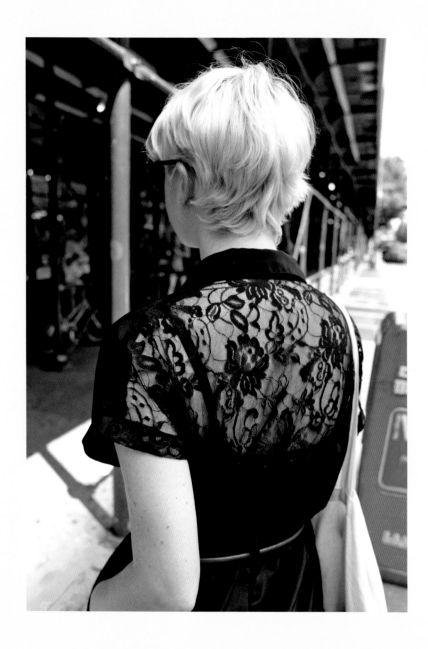

It's okay to vary your shots if a certain part of someone's outfit is particularly intriguing. The subject doesn't always have to face the camera.

of focus. We have never encountered this problem ourselves, so if you use lenses that we suggest, you shouldn't have any problem. This sort of issue usually comes up in studio photography and macro photography, where different kinds of lenses are used.

POST-PRODUCTION

Only half of what goes into creating a professional street style photo occurs in the actual taking of the photo. The other half occurs behind the scenes, in post-production. The editing is just as important as taking the picture and will propel your photos from good to extraordinary. A little editing and light correction can even salvage what would otherwise be an unusable photo.

Editing

Before we begin with this section, we have an important tip to recommend to you: Think of editing as applying makeup. Editing should enhance what is naturally there, not completely change what you shot. Go for a natural look, don't apply so much makeup that it becomes a clown's face. Many amateur photographers go overboard with lens flare effects, 1970s-style faded tints, sepia tones, over-saturated colors, and extreme contrast. Don't fall into these traps. You are free to discover what works best for you as you develop your own style, and you certainly don't have to do exactly as we do—just remember that fashion at its best often conveys class, sophistication, and refinement. Imagine Leonardo da Vinci painting gaudy colors onto the Mona Lisa, and sprinkling glitter over it. Why "fix" something that is already beautiful? Food for thought.

To edit all photos and images on theSFStyle.com, we use a combination of iPhoto and Photoshop. Apple computers and software are very well suited for working with photos, but most computers with a decent photo-editing suite will have the same basic functions as iPhoto. So most, if not all, of our tips here will apply to you even if you don't use iPhoto.

Adobe Photoshop is expensive, and is not absolutely necessary. Its advanced features can be more than you need for minor street style edits. But it certainly doesn't hurt to have it if you've got the bucks to spend. Adobe Photoshop can also be useful when optimizing your photos for Web use. We'll talk more about Web optimization momentarily.

Selection

The first step is to review your images and select the best ones of each subject. It's okay to choose several, even of the same type of shot—you can narrow your selection after editing.

Optimization for the Web

If you plan to post the photos online, you need to optimize your photos for Web. High-resolution photos are usually very large files, and multiple large files can slow down load time on a blog or Web site. Remember that not everyone who comes to your blog will have a fast computer and Internet connection. Some users may even be viewing your images on their smart phones. You want to make your blog load as quickly as possible, lest you lose potential readership due to latency issues. Smaller size photos are easier to work with in general.

We use Adobe Photoshop to optimize photos. Once you have

your photo open in Photoshop, you select the FILE tab and go to SAVE FOR WEB. This sometimes takes a minute. You'll see that it offers you an optimized version of your photo, which probably looks to you exactly the same as the original version, except that the image size is far smaller. Go ahead and save the photo, and you're done! Most older computers are brought to their knees by Photoshop since the program hogs a lot of your computer's memory—so do not open too many large-file photos at once. We recommend five to eight images, depending on how much memory your computer has and what it can handle.

If you're working with large file sizes and don't have a program for optimizing photos, a "cheat" is to take a screen capture of the photo. This significantly reduces file size while maintaining high enough quality for Web use. To take a screen capture on a Mac computer, hold down Command + Shift + 4, and crop as you like. To take a screen capture on a PC computer, hold the ALT key, click on the image, then press the PrntScr key. You have now saved the image to your PC's clipboard. Open up Paint, which is standard in any Windows OS, and paste the image by holding Ctrl + V. Done! Now you can save the image in the desired format.

Cropping

Once you've optimized your selected photos, you can drag and drop them back into your photo editing program. You will want to go through and crop and realign your photos to address composition and balance. Play around and see what looks best. You can crop out unsightly objects at the edges of the photo or crop down to a particular subject to focus on, such as a purse or shoes. Ideally though, you should have some close-ups of those items already in your reel.

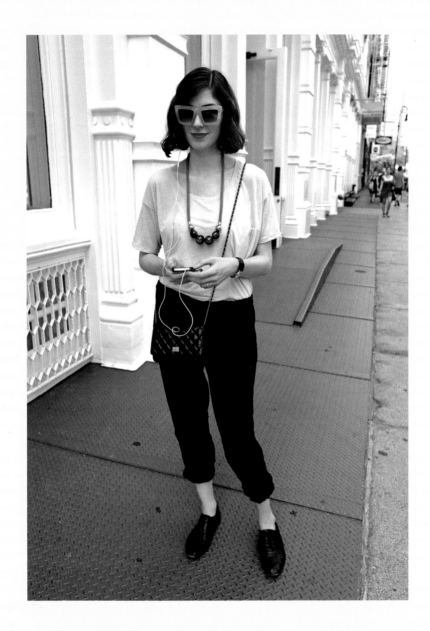

We made the mistake of shooting this subject's white top on a white background, but the photo was salvaged by adjusting the "Highlights" option in iPhoto. Many basic photo-editing programs have this feature, and its main purpose in street style photography is to make light parts of your photo more distinct.

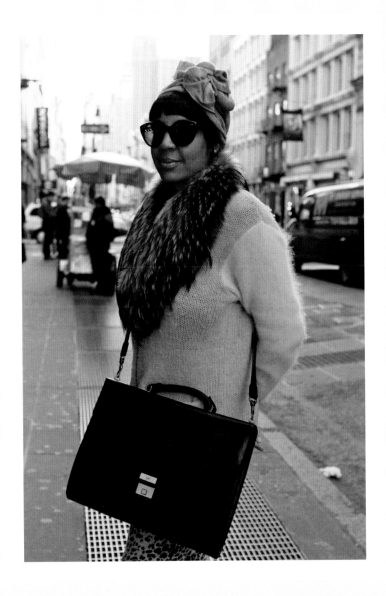

This photo had a very bluish tone to it due to the shady natural light. It was corrected by increasing the red tone and lowering the green in post-production.

Lighting Correction

Correcting the lighting will make the most dramatic change by far in the post-production process. iPhoto makes this practice very fast and easy. The most basics steps to correct lighting are:

— Hit the EDIT button.
— Start by hitting ENHANCE. This usually helps, but if it does not make your photo better, you can hit UNDO.

Don't worry if your photo is overall better, but still a bit too dark or light. That can usually be fixed.

— Go to the EFFECTS and ADJUST tabs.
— In the EFFECTS tab, hit BOOST COLOR.
— If the photo is improved, let it be. If not, UNDO.
— In the ADJUST box, begin by moving the levels up and down to see how your photo reacts. We start with the top right-hand level adjustment, and work our way right. These sliders darken and lighten certain areas of your photo. The goal is to make the colors of your photo as vivid and pleasing as possible without going over-board by overexposing or underexposing your photo.

All of these changes can be undone, so don't be afraid to play around. Try moving the adjustment bars to their maximums and gradually lowering them to an acceptable level.

Details and highlights are used to show more of the details in certain areas. Use these features sparingly, as too much will cause your photo to look very odd. Both are useful to make a washed-out background more visible, but pay attention to your subject's skin, since these adjustments often adversely affect skintones.

Shadows affects just what you would expect—the shadows in your photo. This is extremely helpful. Use it to correct any shots that may have a little too much shadow obscuring important areas of the photo. Remember that a bit of shadow is good for contrast, and photos without any shadow at all can look muted and unnatural.

Saturation controls how much color saturates your photo. It is useful to boost color in photos that rely heavily on how striking the color is. This is often the case on close-up shots of bags and accessories. If you have done the steps in the order we've laid out for you so far, you will rarely need to adjust saturation by much.

Temperature and **tint** essentially adjust the amount of certain colors in your photo. They are the second most dramatic change in the editing process. You'll use these often to reduce the yellow/red hues in photos that are taken in very bright spots or in poorly lit indoor areas. You can also reduce the amount of blue in shadowy, overcast photos. You'll want to use this tool in moderation, and remember that any color adjustments made should be balanced. (If you increase the temperature level to make a photo more warm looking, you may need to increase or decrease the tint level to keep the colors looking natural.)

Sharpness Who doesn't like sharpness, right? You might be tempted to boost this up to max on all of your photos, but we caution you to use restraint. You really only want to use this tool on photos that aren't already sharp to begin with. Oversharpening runs the risk of making your photos appear too pixilated. We find this feature most useful in close-up shots of accessories. Try to avoid oversharpening images that include human faces.

Reduce noise is our personal favorite secret weapon. It essentially makes the entire photo look like a painting, softening the whole image and reducing the "noise" (aka grainy appearance). We try not to use this unless needed, because it is like adding a layer of makeup to EVERYTHING. It's good for photos that are too sharp—because let's face it—nobody needs to be able to count every one of your model's pores. We use this tool to soften skin tones and details. But it's also a good way to resuscitate a photo that turned out slightly blurry or otherwise unusable. As always, don't use it unless it is needed, and even then, only in moderation.

Blemishes Since we don't travel with a full hair and makeup crew for our models, we will often take it upon ourselves to add a little "concealer" or "delint" someone's attire in post-editing. It is considered a common courtesy to edit these out for your subjects.

This rule also applies to any close-ups on hands and shoes where the nails are exposed. Street style photography being what it is, your subjects are not likely to have come straight from the salon. If they're wearing a particularly striking shade of nail polish that you plan to showcase, do them a favor and remove any chips to make it look as if they just had a mani-pedi. You'd want the same.

You can also remove visible lint or lose strands of thread from an outfit. Hit the RETOUCH tool. Adjust the size of it as needed, and slowly click over blemishes and any undesirable spots on the photo. Use this judiciously, since going overboard can make your retouching obvious.

Once all those steps are done, you can sit back and bask in the glory of how your photo now looks. There's a REVERT TO ORIGINAL button under the PHOTO tab if you change your mind on any alterations you made. If you save the new photo to your

desktop and revert the iPhoto copy back to original, you can compare the two and see the dramatic difference.

UPLOADING AND PUBLICATION

You are now ready to upload your photos to the Web. Many blog platforms let you upload directly, but they often reduce the size of your photos by lowering the resolution drastically. This can essentially destroy all the hard work you've just done. Don't let this happen. You will want to upload to an image hosting site and link to your photos using HTML. We use Flickr and have never had any problems. Flickr.com has free account options, but Pro accounts grant you unlimited photo uploads and unlimited storage for a very low annual fee. While Flickr has become an industry standard for bloggers, other similar sites offer comparable options.

Once you've uploaded your photo, you are ready to do some HTML coding to post the image onto your blog!

HTML Code Basics

Here is the basic html code to post an image to your blog:

```
<img src="insert the URL of your image on flickr or whatever hosting site you use"/>
```

Pretty simple, huh? You don't have to be a programmer to post images on a blog. There's more, but that code is all you need to know to start. Of course, additional html codes will help you customize your photos and blog posts. Turn to page 154 in our resources section for more information.

A lot of people feel nervous or shy when staring directly into the camera's lens. Suggesting that they look off camera can put them more at ease. This in turn helps them to relax their whole body language. Aid your subject to become even more photogenic by taking photos of them from multiple angles. One of the benefits of digital cameras is that you can review the film as you go. Stopping for a moment to check your reel between takes will help you to find the angle most flattering for your model's features. Remember, everyone is unique and will have different angles that are best suited to their particular features.

L: One of the most alluring aspects of street style photography is how it always keeps you on your toes. Sometime a few seconds is all the time you have to assess the lighting, uncover your subject's optimal angles, and compose the shot. The sun was moments from setting when we stopped this gentleman. And after a long day of work, he was understandably in quite the hurry to get home. This photo had to be perfect in just one or two shots, or not at all.

R: We usually engage subjects in conversation between shots—partially out of genuine interest in what they're wearing, but also to make them feel more at ease and relaxed. We love when we can capture people laughing. The images always have such a genuine and joyful feeling. We often take shots of this nature from off to one side to convey their candid spirit. In this instance, it was also important to create a composition where our model's figure stood directly between the two brick buildings in the background.

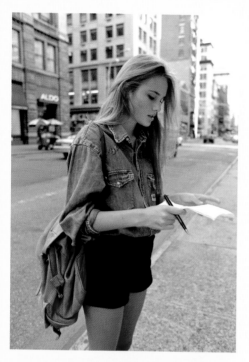
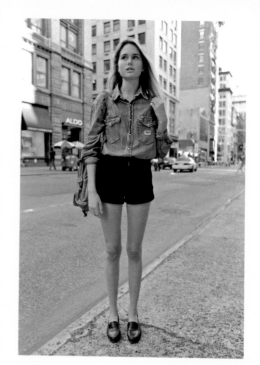
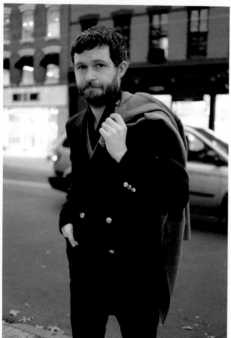
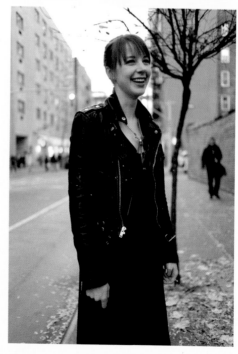

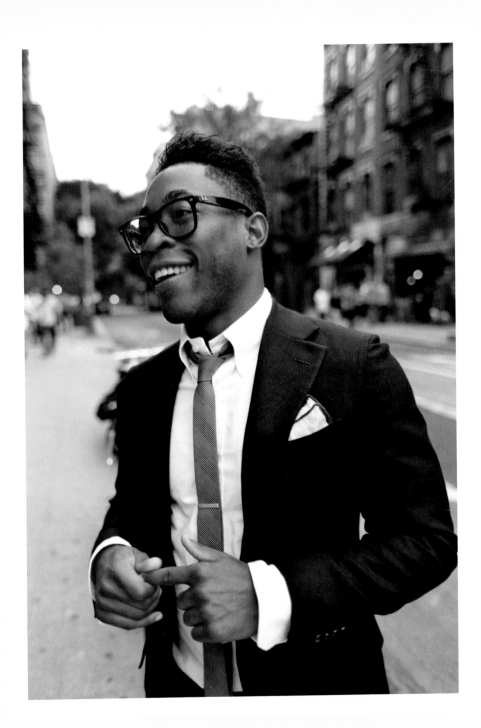

If you are fortunate enough to scout for subjects in a group of two or more—as we do for our own work—you can have one of the team engage the subject while the other photographs. You can get some nice candid shots this way. In fact, take shots whenever possible, even before and after the fact, on the chance you might get a subtle casual shot like this one.

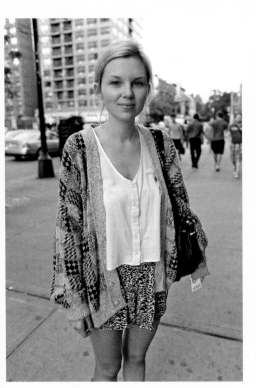
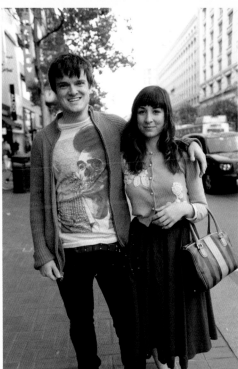

L: When looking for people to photograph, don't rule out the possibility of seeing someone inside a retail shop or cafe and asking the person to pose outside for you. We spotted this adorable lady inside a grocery store in Midtown Manhattan.

R: Make sure that all the people in the photo are looking in the same direction. If one looks at the camera and another looks off to the side, the resulting photo is rarely good. It's just one of those things.

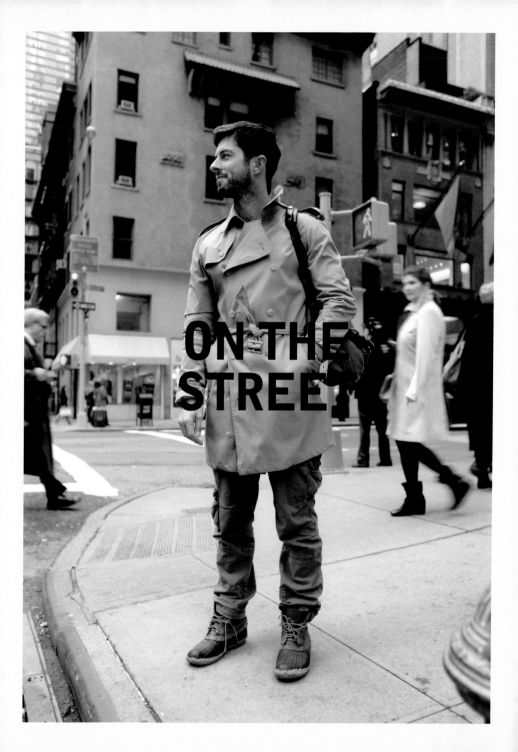

ON THE
STREE

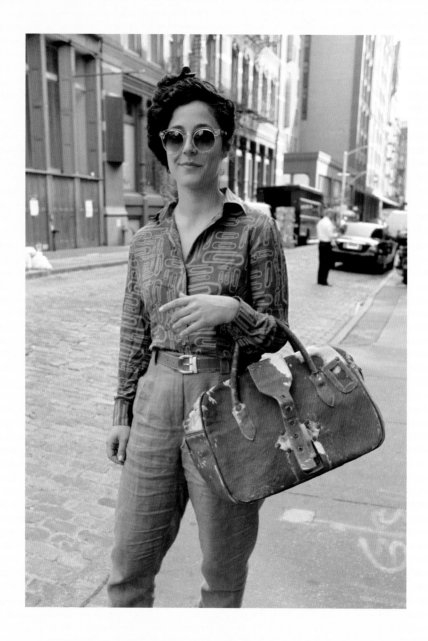

This subject had an entourage close by, and we had to make sure to have
them angled out of the shot. You want as few people in the background of your photos as
possible, because they take away focus from your subject.

SELECTING YOUR SUBJECT

Our goal in this section is to give you some basic tips that will help you translate what you love most about someone's three-dimensional outfit into a two-dimensional photo. There's nothing more heartbreaking than getting back to the editing room and finding that your photos don't really convey what made you fall in love with a person's outfit in the first place. Hopefully, we'll help you avoid those pitfalls.

Living in New York and San Francisco, we pass hundreds of potential subjects on the streets every day. But usually only one or two individuals in the masses will catch our eye. We consider several factors when looking for subjects to photograph: stand out clothing pieces and accessories, contrasting or bright pops of color, innate personal style, or interesting twists on current fashion trends. Whatever you look for in a model, there's no "bad" reason for selecting your subject. However, certain elements will translate better onto film than others. Whenever you take photos—be they street style or otherwise—always ask yourself if the images you're taking are capturing the message that you want to share.

Approaching an Individual

In most major metropolises—and particularly in cities like San Francisco with high panhandler populations—being approached by a stranger on the street can sometimes be a negative experience. So much so that attempting to get an unfamiliar person to stop for you can feel like an uphill battle. As a street style photographer, when you stop a subject, what you're really asking of that person is to take time out of their day to do you a favor. Don't be

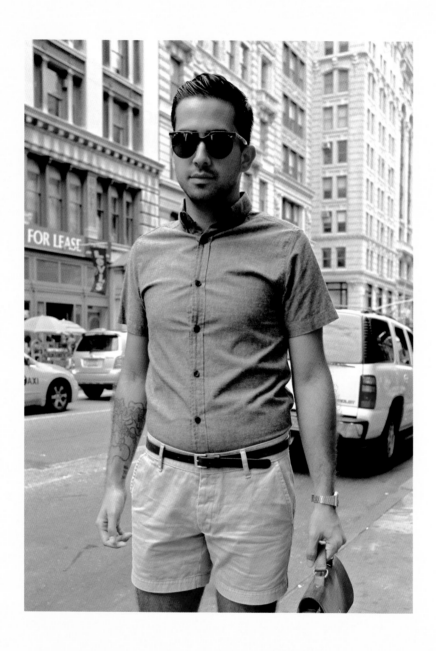

A simpler outfit can be enhanced in a photo by shooting against a background with more intricacy, like the buildings in this shot with many lines and windows.

discouraged if your first attempts at stopping subjects are met with rejection. You get more comfortable with practice.

It might sound counterintuitive, but when we stop people on the street we generally won't introduce ourselves right off the bat. Expect people to have their guard up. If you start with a long-winded explanation of who you are and what your photo project is about, you'll sound too much like a salesperson. Your subject may be skeptical. Instead, break the ice with a compliment. Approach with a smile and tell the person why they caught your eye. "I love all the brilliant colors you're wearing" or "I adore that vintage bag. Would you mind if I took a picture?" It's sweet, simple, and straight to the heart of matters. There's usually no need to wax poetic about how great the person looks. Get right to the point and ask for the photo.

Once you've got your subject disarmed and agreeable, feel free to introduce yourself properly. Always carry a calling card and a friendly, yet professional demeanor. You never know who might be a great business contact later on down the road.

It's unlikely that the exact spot at which you stop your subject will have the optimal photography conditions. Don't be afraid to ask the person to move across the street or around the corner. Make sure to explain to your subject that the reason for the move is better lighting conditions, less foot traffic, and so on. The more involved you make the subject in the process, the more obliging they will want to be in helping you capture the perfect shot.

Be considerate of your subject's time constraints. Ask them if they are in a rush. You can't expect to drag them all around the city looking for the perfect background. If you try their patience, it will be written all over their face in the photos.

The last thing you want is for your subject to look stiff and uncomfortable in the photographs. It's your job as the photographer

to make the person you are shooting feel relaxed. This can prove a particular challenge when photographing someone who is especially reluctant or camera-shy. Taking the emphasis off of *them* as a person can mitigate this. There is a subtle, yet distinct, difference between saying to someone "You look great" and "That outfit/purse/hairdo looks great." While most of us would probably prefer the former as a compliment, the camera-shy person responds more positively to the latter. Taking the emphasis off of *them* tends to make them more relaxed in photos.

Tips for Making Your Subject Feel Relaxed

— Start out by asking to take a photo of a particular article, such as shoes or bag. Lead up to the full-length shot. This approach will put your subject more at ease.
— Ask them questions about their outfit. Be conversational.
— Remember, these are NOT professional models. Be courteous of body issues, because many people are self-conscious about physical imperfections they feel they possess.
— Don't be afraid to take candid shots.

Approaching a Group

More often than not, you will find that a subject who's caught your eye is traveling with companions. Approaching a couple or a group of strangers can sometimes be more daunting than stopping a person who is walking alone. If you find that the whole is greater than its individual parts, you might feel inclined to photograph the pack. Group compositions of friends that dress alike can help drive home a theme or trend that you're trying to convey. If you have the time, we recommend getting some individual shots of each person in addition to the group shots.

But when one subject stands out above the others, don't feel too timid to ask their friends to step out of the frame. Or better yet, separate your subject from their crowd by asking them to move around the corner or across the street. You can always say that it's for a different background.

BACKGROUND

Whatever is behind your subject will be the background of your photo, or in other words, the canvas you are painting on. It's important to have a good canvas, but it's even more important to remember this: in street style photography, the subject of the composition is your model, NOT the background. Don't work too hard to get the perfect beautiful background. It's more important to have a background that doesn't have distracting elements that detract from your model's outfit. Beautiful settings are great, but avoid focusing too much on monuments or significant landmarks, sculptures, or objects. Photos taken in front of something prominent or recognizable run the risk of looking like tourist snapshots. Even when the photo is well executed, the landmark might still divide the viewer's attention and detract focus from your model.

People, cars, and other moving things will inevitably find their way into the background of your street style photos, cluttering up the frame. There are ways to mitigate this problem:

Timing. Simply be patient and wait for things to pass.
Displacement. Move your subject to a less crowded area.
Angling. If you're pressed for time, you could angle the camera and your model so that distracting elements are far in the background or completely out of the frame. Sometimes, you can also

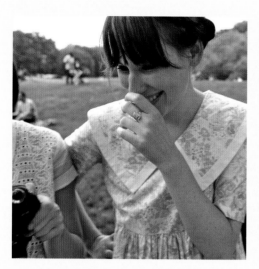
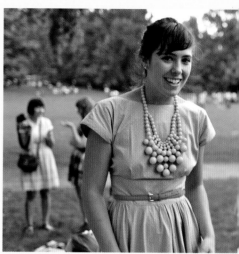
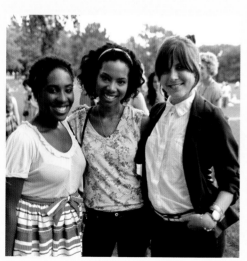
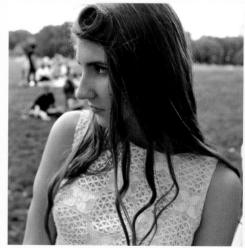

When photographing at an event, try mixing in candid shots along with the posed ones.

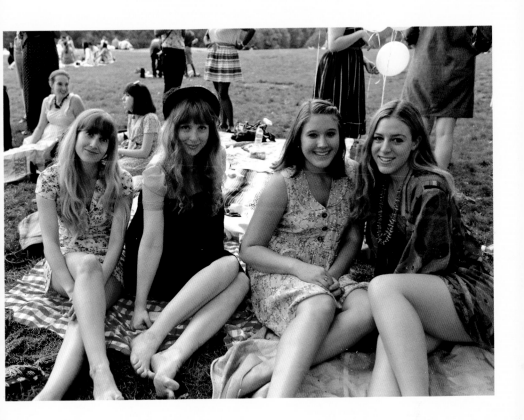

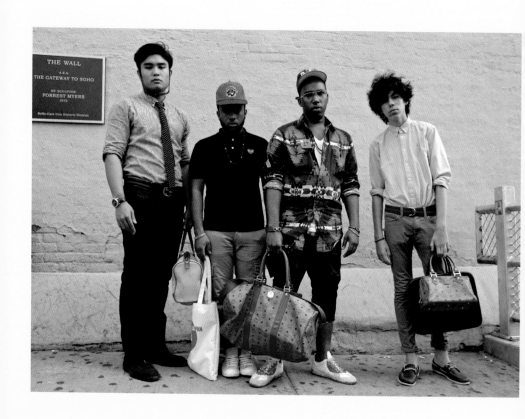

As we've mentioned, group photos can be difficult—but when they work they are magnificent. Make sure to take individual shots of the subjects as well, in case the group shot doesn't turn out as you had hoped.

L : Shooting more than one subject at a time can be challenging, since it doubles the chances that someone is blinking, moving, or just not making a flattering expression. Try to make sure your subjects stand parallel to each other, and not too far apart. A lot of times when you're stopping a pair of friends or a couple, their natural rapport will enhance the shot and make it twice as good!

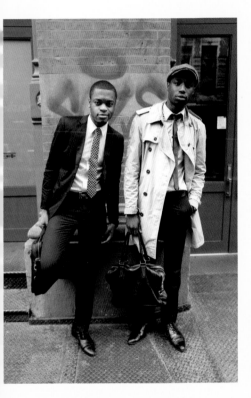 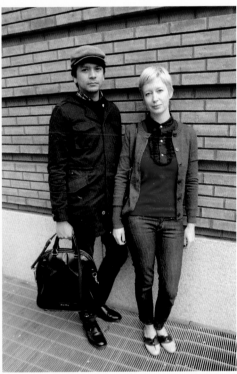

R : You have probably noticed by now that when we shoot people against a wall instead of standing freely on the street, we usually select spots with nice patterns and textures. There's almost always a good option wherever you may be.

We spotted this modern day Edie Sedgwick traveling with a pack of her stylish friends in SoHo, New York. When we stopped her for a photo she was happy to oblige our camera, but we could tell that she was in a hurry and didn't want to hold up her friends. We asked her to go across the street for a chance of better lighting. She was a hint reluctant to abandon her companions, but we assured her that the shoot would only take a minute.

Even though the part of town we stopped her in is actually quite picturesque, we opted instead to use this abandoned, graffitied lot as the backdrop. The lot itself lent a great deal of depth to the composition, and the muted colors provided a nice contrast to the dark silhouette of her outfit. For the close-ups, we were careful not to have the white billboard directly behind our subject's head. The white background would have washed out her blond hair and light skintone.

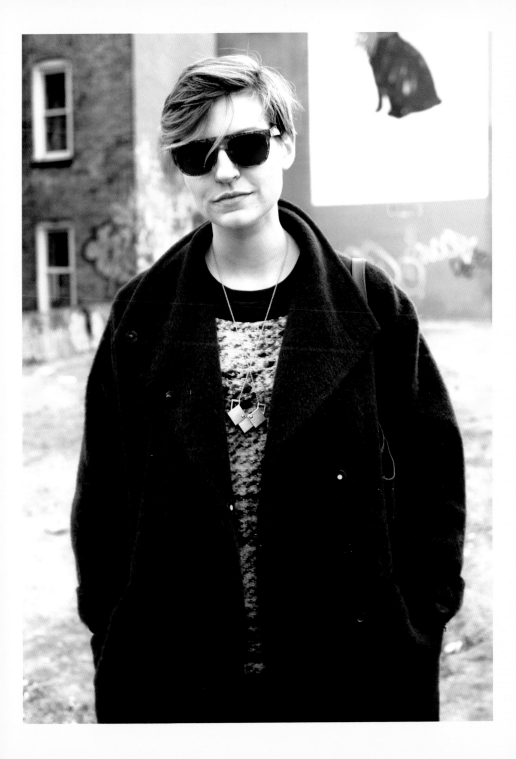

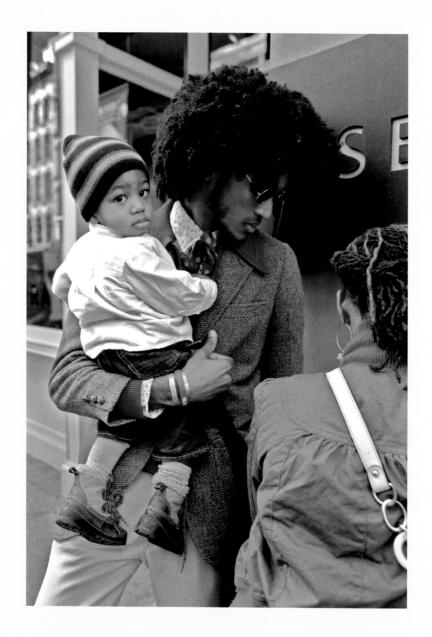

We originally wanted to photograph this groovy gentleman solo, but he literally had his hands full. He agreed to let us take some candids, and it really paid off with an adorable moment captured.

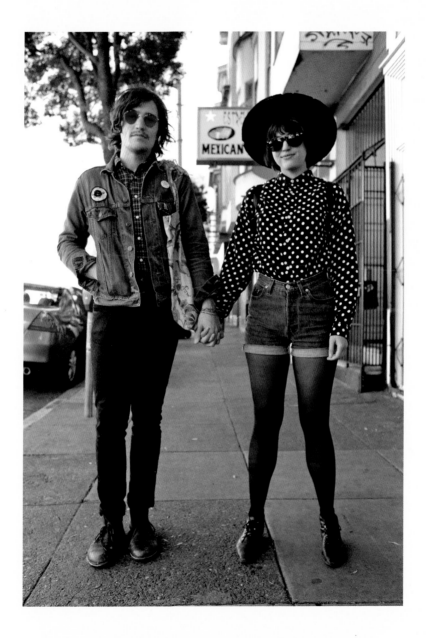

This is one of those instances where the natural affinity of the subjects
helps to enhance the overall outcome of the photo. When you have a pair as insouciant as
these two, let them continue holding hands.

L : This is a great example of how an exquisite backdrop can enhance a photo without distracting from your subject.

R : If the background has some sort of height variance—like this shot does— try to incorporate it.

L : Be wary of distracting things in the background, like a garbage can or pile of cardboard boxes. You don't want people to look at your photo and pay more attention to what someone is doing in the background, either. You don't have to avoid these things completely though—in this shot a pile of flattened boxes can be seen, but barely.

R : We wanted the compositional elements in this photo to convey a very specific point in time and space. Between the piled up evergreens for sale in the background and the word "SOHO" on the shop just behind the subject, you get the distinct presence of December in Manhattan. We also chose this background because we wanted the green accents from the bike lane and window trim to draw attention to the woman's beautiful skirt. The close-up on her midsection was necessary to highlight the skillful mix of textures in her ensemble—detail that would be otherwise lost in a full-length shot.

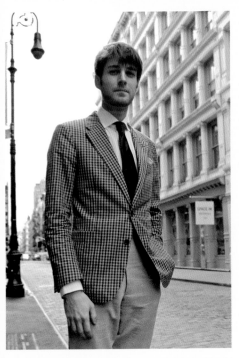
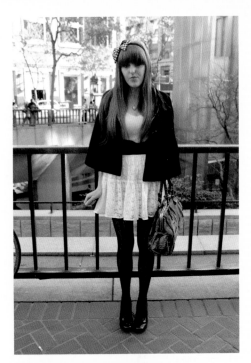
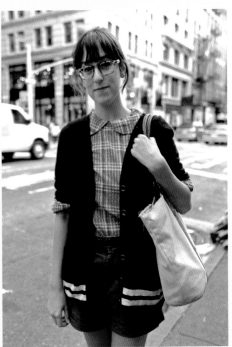
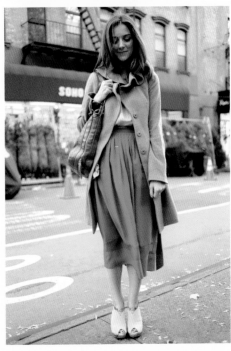

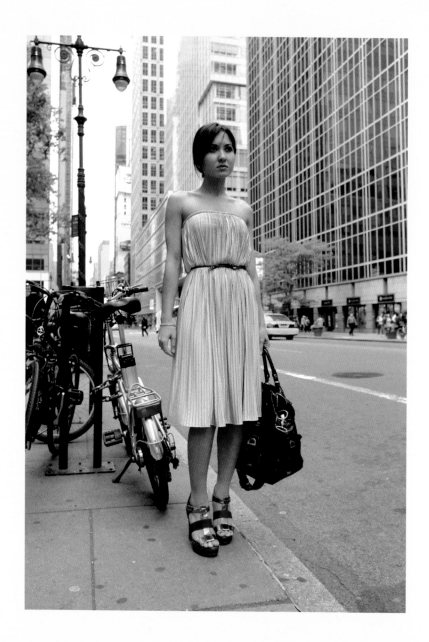

Choose your background thoughtfully. This shot was taken right next to the iconic fashion show location of Bryant Park—but we shot facing away from the park, since the lines of the buildings complement the lines in the subject's dress.

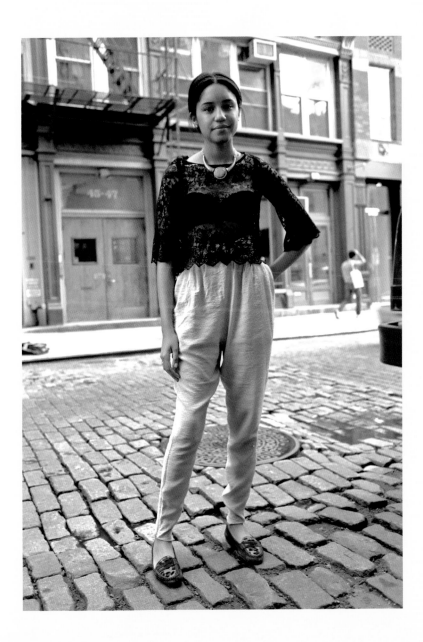

Sometimes your location will have beautiful details, like a loose-stonework street and striking architecture. Take a moment to look around your current location for the best spot. There are endless possibilities, even within a thirty second walk from where you are standing.

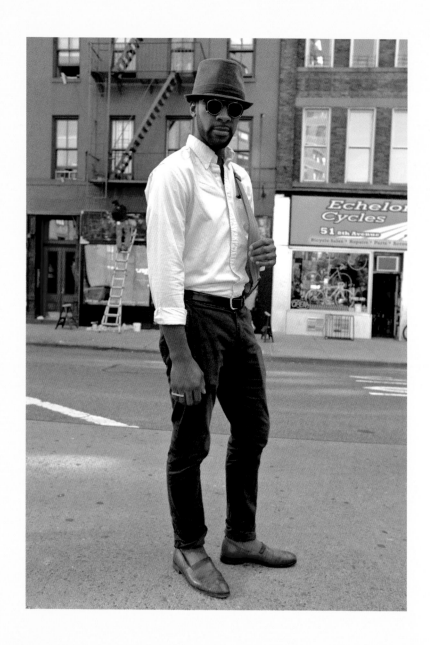

Signs and banners can be a major distraction in your photo. In this photo they are far enough away from the subject and cut off by the frame that they cease to be a problem and instead become an innocuous, incidental part of the scene.

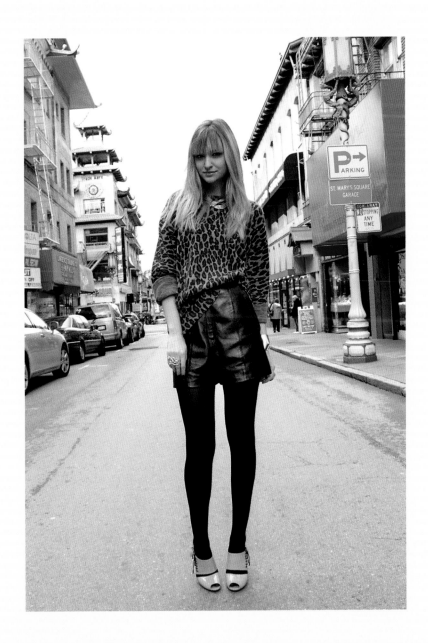

Even when shooting in a very picturesque setting like San Francisco's Chinatown, we still let the subject be the main focus. Try to always stay mindful of your subject so that you don't run the risk of your photos turning into tourist snapshots.

L: There are many, many people directly behind this man, and the shot shows how you can angle a crowd out of the shot and not have to wait for them to pass by.

R: There are times when having people in the background isn't necessarily a negative attribute. This photo makes use of the interesting background pedestrians but keeps the focus on the subject by literally keeping only him in focus. It's pretty easy to achieve this when the other people are walking and your subject stands still.

L: You want to avoid shooting where there are a lot of pedestrians walking through the frame. Never have anyone (or anything) directly next to your subject. If you find yourself in a tough spot with too much unavoidable foot traffic, then ask your subject to move to a better location. Take the person to a curb or find an unconventional hideaway. This photo was taken in a blocked off patio in front of a closed restaurant. The alcove provided a nice sanctuary from pedestrians entering the shot.

R: In congested cities like San Francisco, parked cars are unavoidable. If there happen to be automobiles in your background, try to have your subject stand between them to let the cars frame the shot. This will help to make your subject pop.

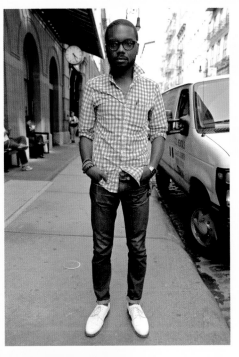

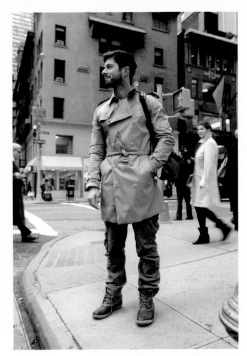

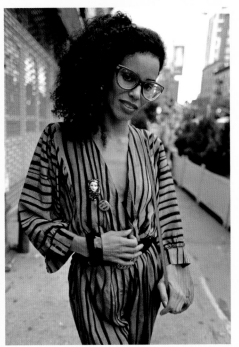

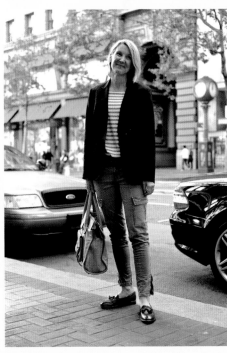

One trick you can use to avoid pedestrians walking directly next to your subject is to ask the person to stand right up next to the curb. This photo was taken on one of those beautiful Indian summer days that New York is famous for. It seemed like all of Manhattan was out on the streets that afternoon. In this instance, putting our subject against the curb served a dual purpose, because it allowed the black asphalt of the street to contrast with her cream-colored skirt. If we'd placed her against a white building or light background, her outfit would have been completely lost.

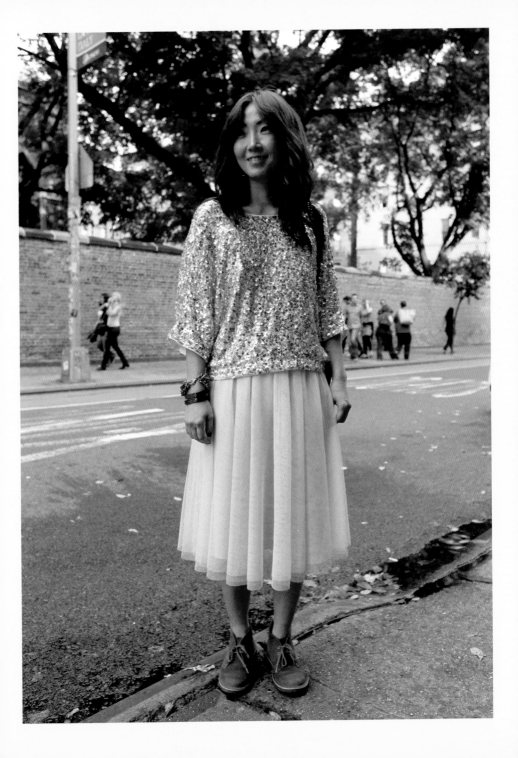

time the shots so distracting things are directly behind your subject, and thus completely blocked. That takes timing, and is especially useful when angling pedestrians out of a shot.

Bokeh

Higher-end cameras with the right lenses will—under certain conditions—produce a bokeh effect, which is the blurring of things that are behind or in front of the area you're focused on. Distracting objects can sometimes be rendered non-distracting if they are far enough away from your model and are blurred in the shot.

Wall

If all else fails, place your model in front of a wall. This is a last resort, because the location and background are part of what makes street style photography unique and special—but it's okay to use a wall now and then. It can be a nice change of pace from the way your photos normally look. If you do end up placing your model in front of a wall, trying angling slightly off to one side or the other in order to create diagonal lines in the composition.

FOREGROUND

Ideally, the only thing in the foreground should be, well, the ground. You really don't want anything in front of your model, lest you detract attention and focus from your subject and their outfit. Some photographers use the technique of shooting their model through a small window or behind the branches of a tree. This technique can create some interesting effects, but is rarely used for street style photography. Remember that the first priority is to focus on your model, so let their style be the star.

L : This one is obvious: We used the wall lines to contrast with the wavy lines of her cape.

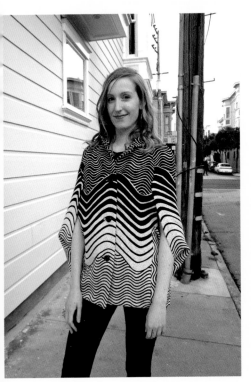 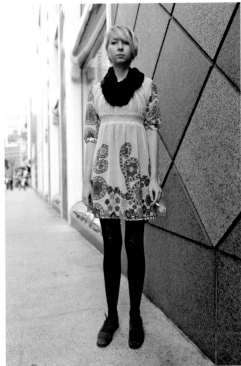

R : This is a solid example of how to keep the background in the shot even when shooting against a wall. Try to include the background whenever you can. It really gives depth and weight to your shot.

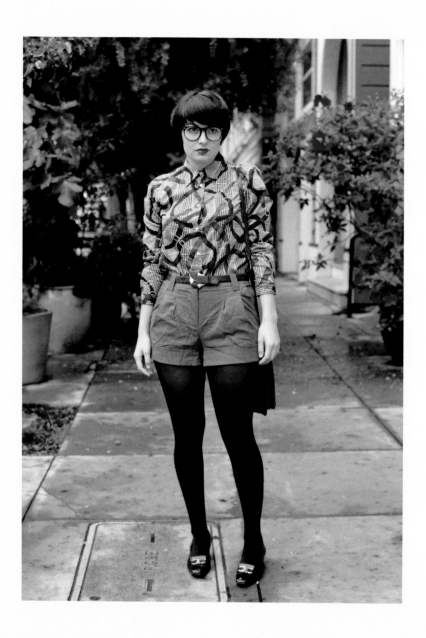

Bokeh blur is most easily achieved when the background has a lot of depth. In this photo, the trees and plants are at least ten feet behind the model, so the background is nicely blurred while the young lady is in sharp focus. This helps the subject to stand out in a strong way.

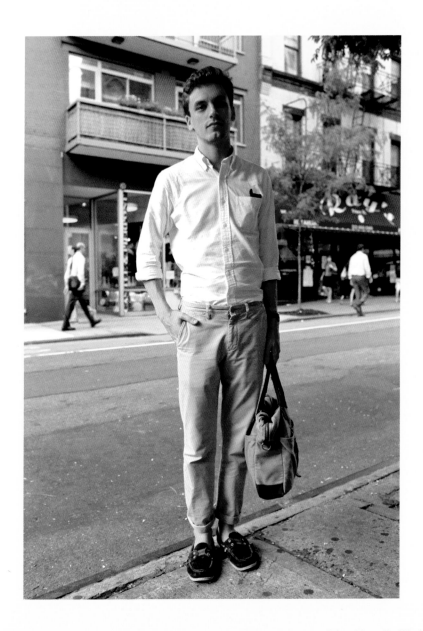

You'll notice many of our photos have the subject standing at the edge of the sidewalk. It helps keep the background far enough away that you get enough bokeh blur to minimize the distractions. You will also not have to worry about blocking off the sidewalk and dealing with people passing directly in front of your shot.

Head to Toe

To display a subject and their outfit in its entirety, you will have to turn your camera 90 degrees and take a vertical shot. All the same guidelines apply. As you frame the shot, it is standard practice to place your subject in the center of the image, but don't be afraid to try taking some extra shots with the subject off to one side or another. The off-center position sometimes creates an interesting photo—especially if the subject is looking off in the opposite direction. (If they're on the right side of the frame, have them looking to the left, and vice-versa.)

You will want to almost fill the frame with your subject, but leave a bit of border space all around. It is important to do so for two reasons. First, a photo where the subject is touching or cut off by the edge of the frame can look crowded and unflattering. Second, a bit of space will give you leeway for cropping or straightening the photo later on in the editing room. On page 51 we talk about how post-editing can be used to create a balanced composition.

This is one of those rare occasions when the foreground is closer than the subject. The reason this works is that the camera is focused on the subject. You'll notice that both the bookcase on the right and the background are blurred. The end result is a voyeuristic feeling. This technique can be very powerful, but don't overuse it. Too many of your photos shot this way can become very gimmicky.

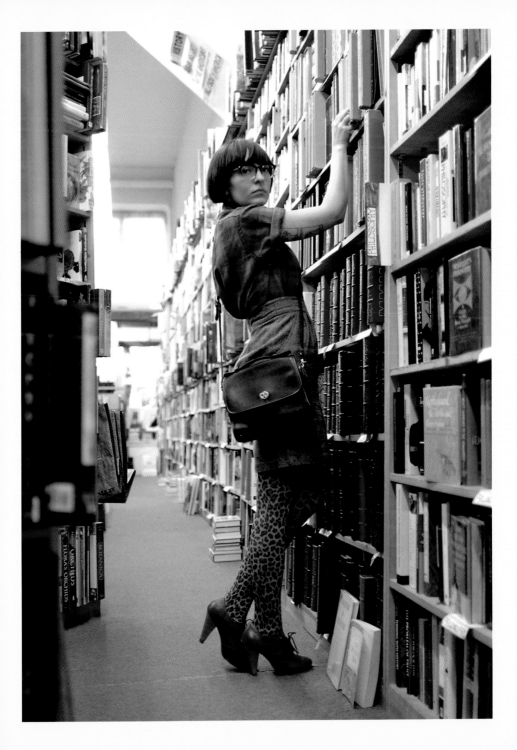

L : Any time you see a row or line of things—like this set of trees by San Francisco's City Hall—use them to create that classic X composition where the elements in the photo form an X with the subject at the crossing point. As you can see, it makes for a really strong impression and a powerful photo.

R : We compose most of our photos in three different ways: slightly angled (like this shot), against a wall, or down a street with the background centered. If your subject has time, try to take one of each kind and see what shots are the best. Not only will you get different compositional results, you'll likely get different natural lighting and different poses and expressions.

L : This simple shot is one of our favorites. Off frame to the right is a falafel cart we thoughtfully angled out of the shot. We could have had the subject put the water bottle away, but part of the beauty of street style is the fact that you're capturing snippets of someone's regular day. So it might be okay if the person is having a smoke, taking a phone call, or holding a refreshment. It's these small details that separate street style from studio photography, and grant it a candid feeling, even when the subject strikes a pose for you.

R : The horizon doesn't have to be perfectly level, because the ground isn't always perfectly level, especially in a hilly place like San Francisco. As long as your subject is level, you'll be fine.

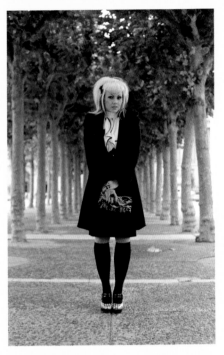
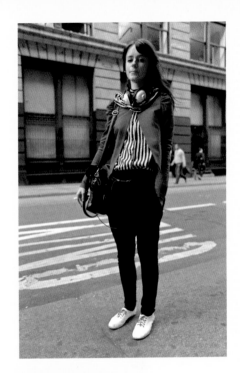
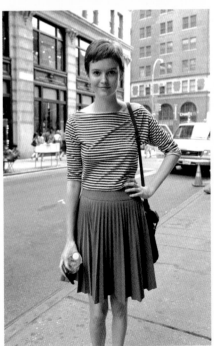
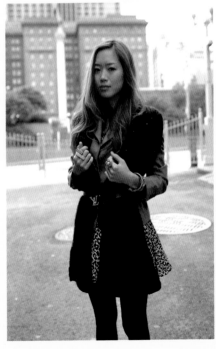

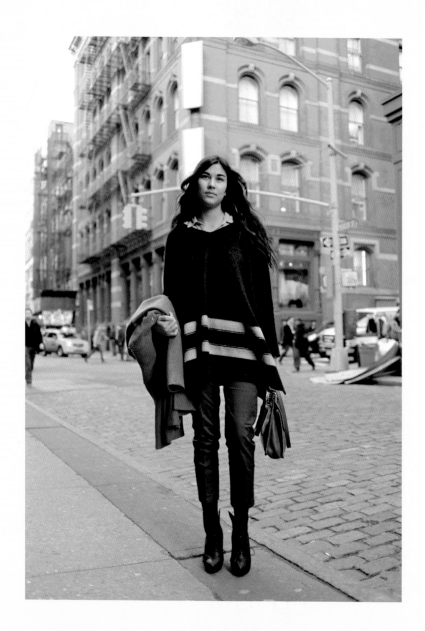

We put a bit more space in this photo than usual. Most of the time, our subjects fill up the
majority of the frame, but variety is the key to keeping your shots interesting, and
some backgrounds just work for these kinds of shots. Again, when time permits, shoot your
subject from different distances as well as angles and choose the one that looks best.

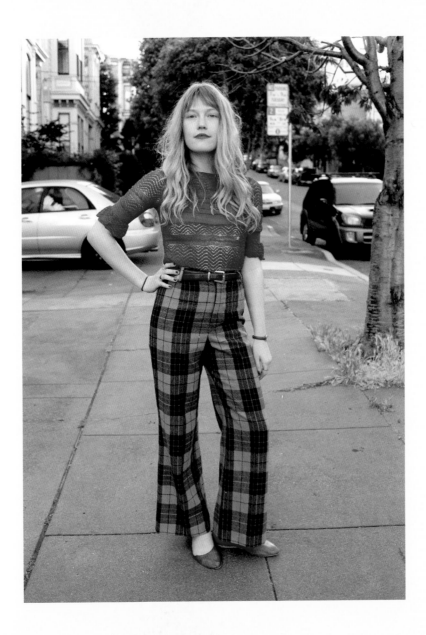

When shooting trousers or jeans with a wider or unique shape, make sure the subject stands in such a way that you can see the silhouette. We also contrasted this woman's blond hair against the green tree, and it worked like gangbusters.

L: We used the arched dome to frame the subject, but it isn't always necessary to center your subject perfectly. This technique will lose its impact if you use it in every one of your shots.

R: Here's a classic example of using the lines of the wall and sidewalk to form an **X** behind your subject. You don't have to do it in every shot, but be conscious of these naturally occurring lines in a background and use them to your benefit.

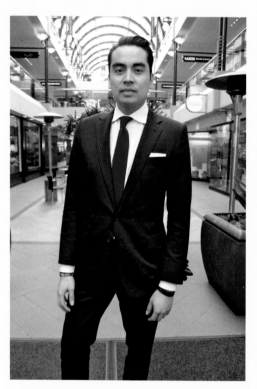 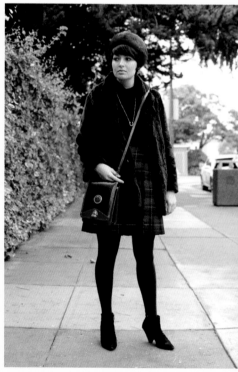

Any bright color can provide a pleasing burst of brilliance to your photo, but you can enhance it further by making sure to shoot against a muted background.

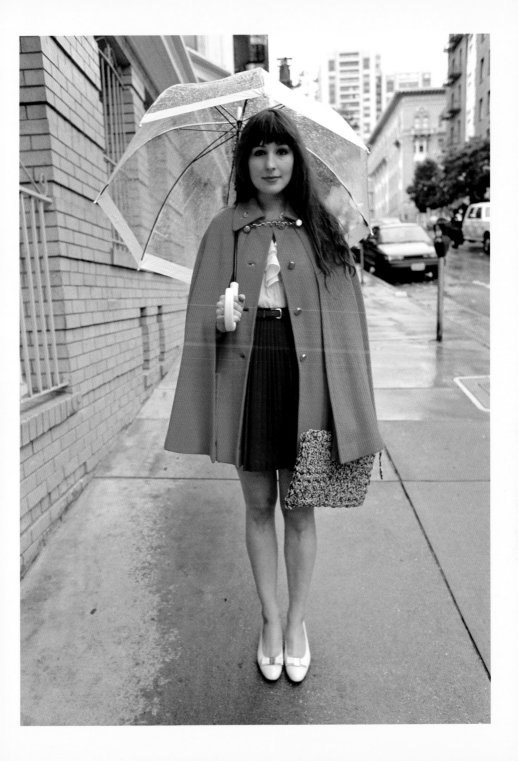

L: We remembered to contrast the blonde hair with a dark green background this time.

R: Always be aware of how much space is around your subject. Leave enough space so you can crop if needed. It also helps to keep the photo from looking cramped. If this photo were framed so the top of the woman's head touched the very top of the photo, it would look odd. You want to fill the frame of the shot with your subject, but not too much.

L: When shooting someone with light-colored hair—like this platinum blond— make sure to contrast it against a dark background. This subject didn't have a lot of time to pose, so we weren't able to place her against as dark a background as we would have liked—but the "Highlights' adjustment in iPhoto was able to give enough definition to her hair that it doesn't get lost in the background.

R: When shooting a person in a single-colored outfit—especially black— make sure you have really good light. If you don't, all the details could get lost in just one solid, dark block of color.

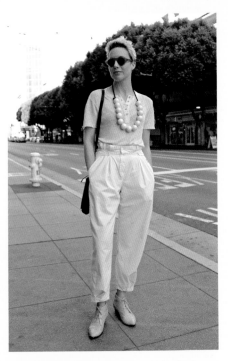
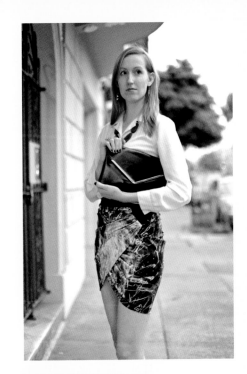
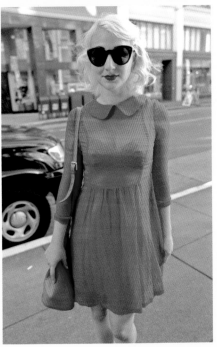
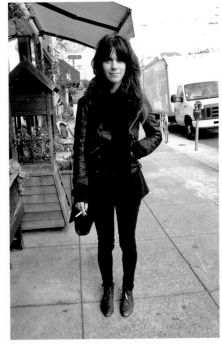

L : We boosted the "Saturation" adjustment of this shot in iPhoto. It gave the lipstick and bag a stronger impact.

R : This was taken with a crop-sensor dSLR, with a lens that had an f/2.8 maximum aperture (not an exceptionally fast lens). You can see that we didn't get as strong a bokeh effect as we would have with our recommended set-up (see page 47). The difference in this photo is that the bus, signs, and people aren't very blurred. It still works, but good bokeh would have made this shot even better.

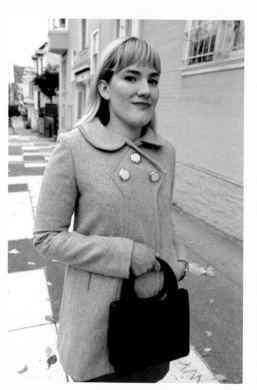
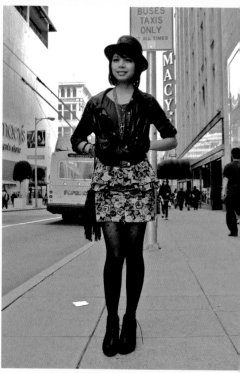

When going for a closer shot of your subject, remember that less is more—
try choosing a stark background.

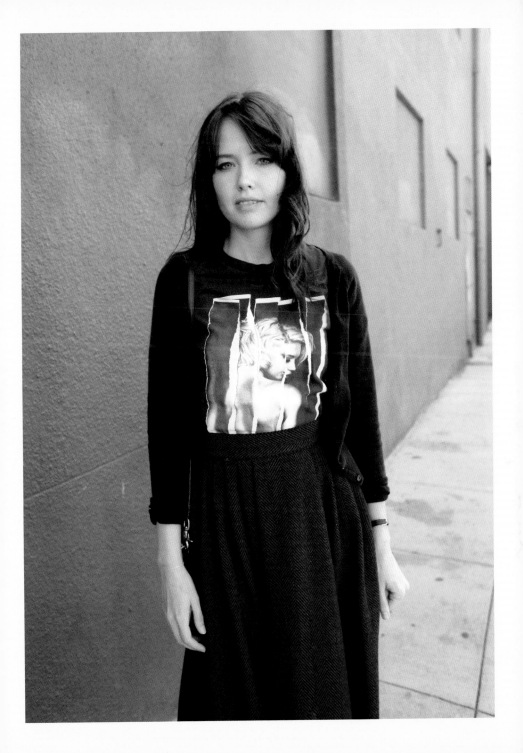

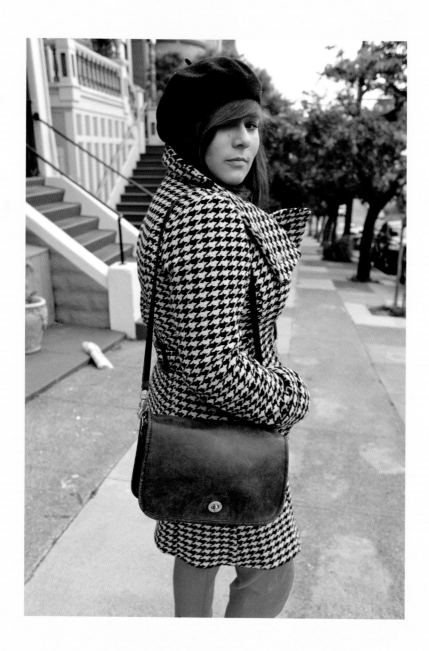

This was taken on a hill. Can you tell?

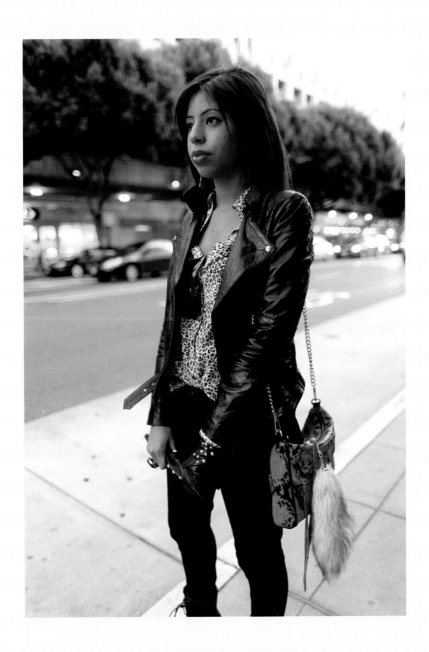

Yes, those trees were very purposely positioned behind the dark hair of the subject. You're getting this now, aren't you?

L: See? This way, when you do center someone perfectly in the background, it is a significant thing.

R: Here's an example of a nighttime street style shot. We used the available light from street lights and a falafel cart that was located just off frame. Be creative and use your natural surroundings to your advantage.

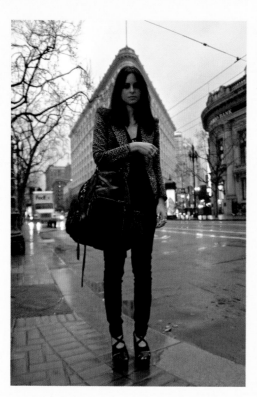 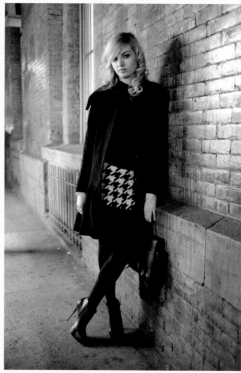

This shot was taken on a dreary day. Although the rain poses a risk to your equipment, these kinds of overcast days provide really stunning light for street style. The cloud cover prevents harsh shadows, and the wet pavement reflects light to your lens.

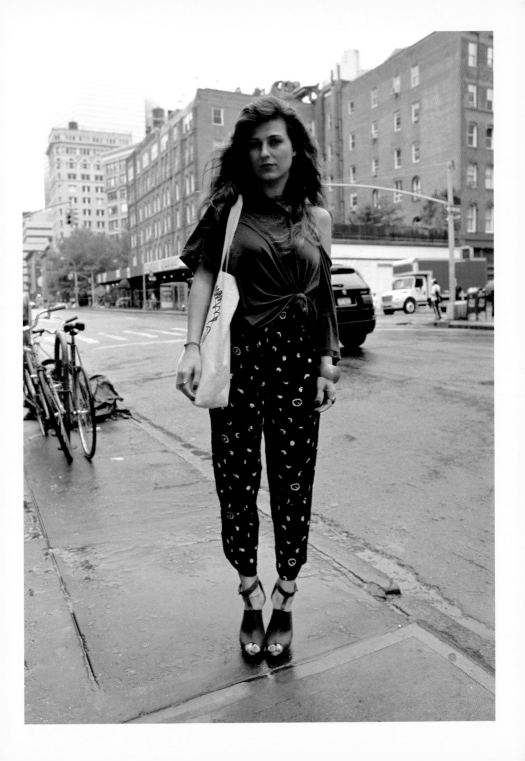

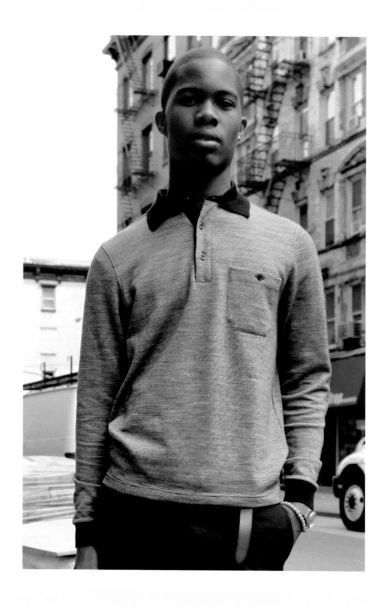

We moved this man around several times to get the perfect light. If the subject
is patient, don't be afraid to try shooting from different directions on the street. The best
photos depend on the quality of light.

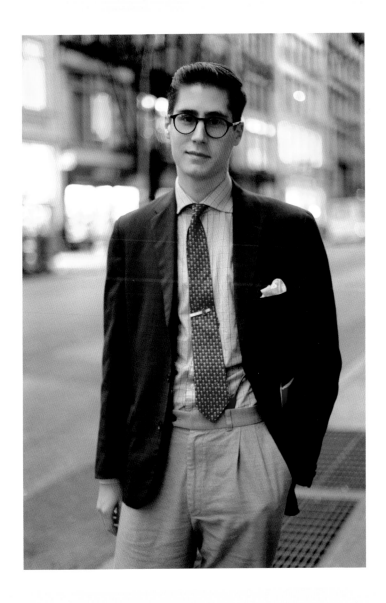

This photo was taken at twilight. The sun had almost completely set, so it was
a little bit past the golden hour. This can be a tricky lighting period to shoot in, and you
will really need to keep your camera steady.

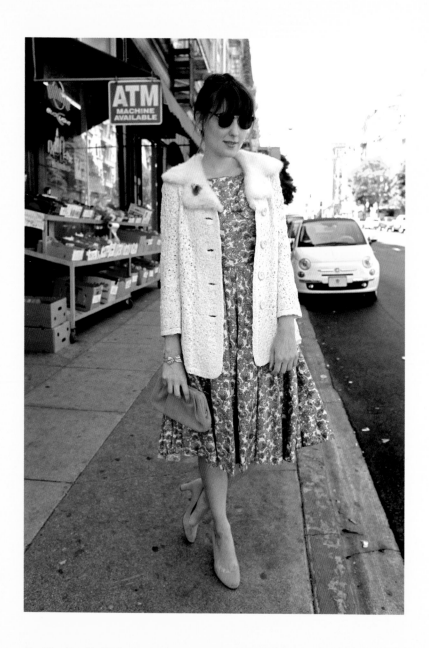

You'll notice that this woman is standing on the shaded side of the street. You will have to experiment with your camera and lens to see what lighting works best, since every camera and lens have different limitations and strengths.

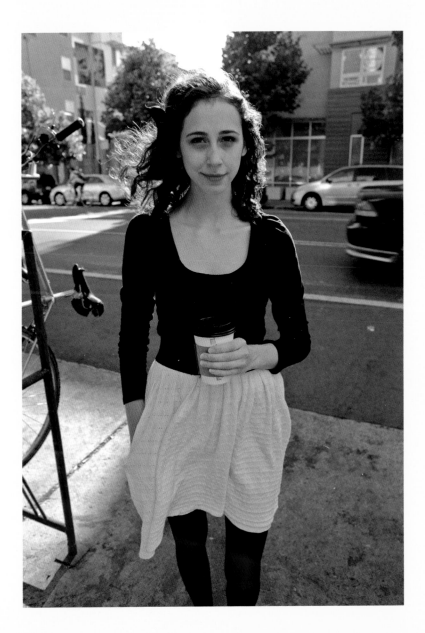

Direct, bright sunlight can cause lens flare effects like the one on the bottom of this photo. Normally we position our models facing the sun so that their features are illuminated. But if you want to experiment with flares, try to get the bright light right behind your subject's head—it lights them up with an ethereal glow.

L : The portrait shot of this young lady is taken at a lower level to use the lines and texture of the background buildings. This portrait has a unique perspective for a three-quarter shot.

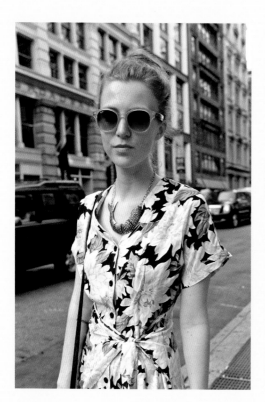 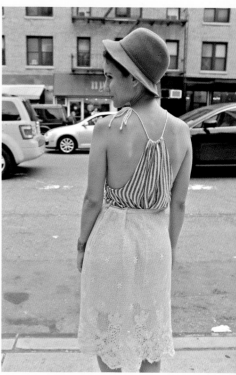

R : When you find outfits that have nice details from the side or back, try mixing it up and taking a few shots from that angle. It will add diversity to your photos and also offer new compositional opportunities.

Three-quarters and One-half Shots

After the requisite head-to-toe photo, if time permits, you should take some three-quarter and one-half-length shots. These are images taken closer to the subject and include only part of the person's body. These close-ups show more detail of the person's outfit and provide a bit of variety to your images. These shots are a great way to showcase what you find most interesting or unique about a subject. The subject may have become more comfortable as you took the head-to-toe shots, and you might get more dynamic shots if you've successfully achieved rapport with them.

What you leave out of a shot is just as important as what you choose to include. These $\frac{1}{2}$ cropped shots give you a way to "edit" your subject's outfit by allowing you to exclude any unwanted aspects of their look and take close-ups of the aspects that drew you to the subject in the first place.

Close-ups

To wrap up your impromptu street style shoot, take some close-ups of any interesting accessories your subject might be wearing: rings, necklaces, glasses, belts, purses, and especially shoes. Often the things we love most about an outfit will be in the accessories, patterns, or textures. These subtle details can get lost in a full-length shot, so it's imperative to take close-ups of the elements of an outfit that drew you in the first place.

These shots are also the perfect time to experiment with different angles, since they usually don't include the subject's face.

Try shooting bags from a low angle looking up. As a general rule, we always try to angle purses so that the full dimensions of the bag are in view. Shots taken straight on help to provide detail, but the perspective can feel flat in a photo.

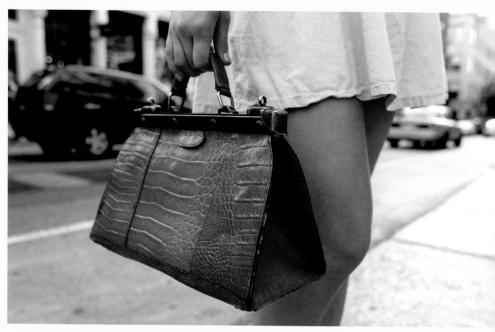

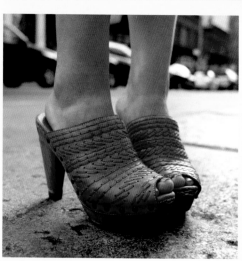

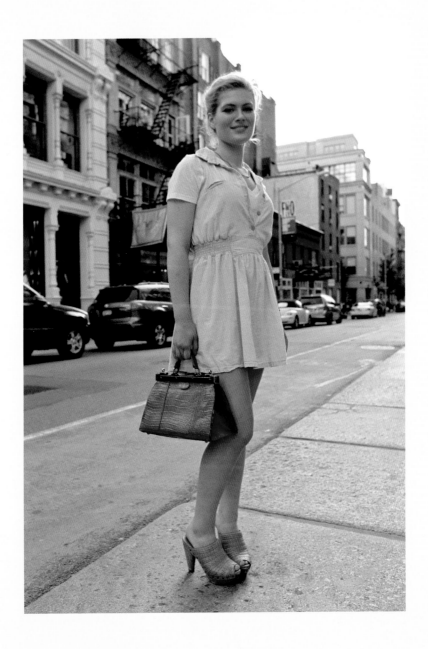

Some outfits are simple, but the standout pieces make it spectacular. This young woman had the most amazing vintage accessories, each of which warranted its own close-up.

Try shooting upward for close-ups of items, since you rarely have the opportunity to use that upward camera angle. This unusual view will give variety the perspectives in your shots.

Having your subject cross their hands is an easy way to get all of their rings in one photo.

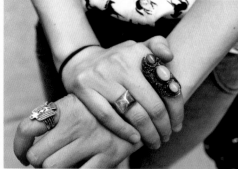

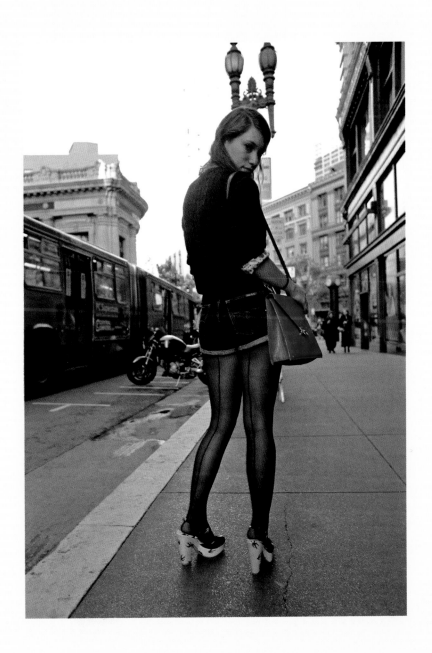

Here's another shot from behind to illustrate a detail of an outfit.

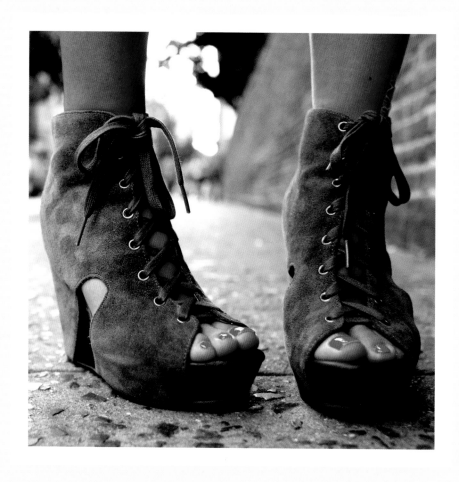

We'll usually ask our subjects to kick one foot out so that we can photograph both angles of their shoes in one shot.

When photographing rings and watches, we'll generally have the subject hold out their hand and shoot from the top.

We prefer to shoot shoes at their level—that is, get the camera down near the ground and have the lens pointed straight at the shoes, the same way you would hold the camera at eye level to photograph someone's face. We recommend against pointing the camera straight down at someone's shoes from your eye level. When you do this, you lose the dimensions of the shoe and have the disadvantage of shooting against a flat background. Getting up close to the shoes at ground level will capture more details and add a contextual background, which usually includes people and buildings. This makes a more dynamic photograph. The angle of the photo will better feature the shoes and the background will tell a story.

Environment

It's street style, so you will be outdoors most of the time. That means that the weather will be your best friend and your worst enemy. You'll face wind, rain, movement, and evening light.

Wind. Even the most pleasant days might have some degree of wind. This is not too much of a problem, since most cameras are fast enough to capture a good photo despite minor wind movement (as long as your model stands perfectly still). One problem you might encounter is wind blowing hair into your model's face. When this happens, ask your subject to angle their face into the wind so that their hair blows back behind them. This will make your photo more dynamic. If the wind is too strong, try to find a wall or corner to duck behind. If it's so strong that taking shelter does not help, it's probably not a good time to be photographing at all.

Rain. Worse than wind is rain, since rain usually entails wind as well. The most important factor to remember is the danger the rain poses to your camera and equipment. I'm sure you know that moisture and electronics are NOT friends. We do not recommend risking your expensive gear by shooting in any situation that might expose your camera to water. However, if you insist on taking the plunge, at least get a protective cover designed for shooting in such conditions. At the very least, you'll need something to cover your camera from the rain as much as possible and you'll have to wipe off your camera's lens area.

Movement. Street style photos look best when the subject is sharp and the details of their outfit can be clearly seen. This is achieved by having both the model and your camera as still as possible when you shoot. A good camera and lens can handle a small amount of movement provided that lighting conditions are ideal, but minimizing movement will improve your chances of getting a truly crisp, amazing shot.

At times you may be shooting on something unstable, such as a boat or subway train. Just remember that the model, not the background, has to keep still. If you and your model are on the same part of whatever is moving or vibrating, chances are you'll both be shifting at exactly the same time. So it IS possible to get a decent photo, it just won't be easy. Steady yourself and take as many photos as possible. Remember: The best photos are often taken under adverse conditions.

Evening light. Shooting at nighttime creates a whole slew of obstacles that you might not have previously encountered if you've only shot during the day. The most obvious is the absence of natural light. But there is also the factor that wandering the streets at

L: It was a windy day, can you tell?

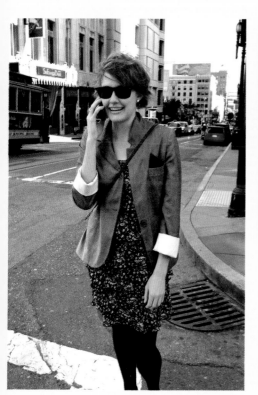 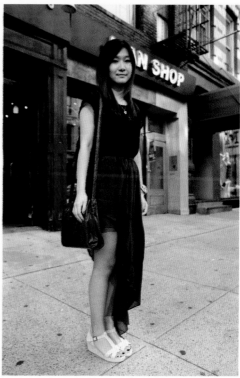

R: This shot was slightly challenging because it was actually a little windy, and it made the woman's skirt flare out oddly in many of the shots. We ultimately went with one of the shots where the breeze had died down. This way, the true silhouette of the skirt is easier to see.

night can be dangerous—both for yourself and others. Be extra careful when guarding your equipment. This element of hazard can also make potential subjects twice as wary of being stopped. Be sure not to "creep up" and startle your subject.

The quickest fix to the lighting problem is to use a flash, but that gives a whole new set of considerations. If you are shooting in the evening sans flash, you've got to have a camera with a good ISO capability and the STEADIEST of hands. You'll be surprised what is possible if you have a good camera and lens. Many newer cameras are capable of capturing far more details in darker situations than you can see with your own eye. Do your best to find any nearby light sources. Even at night, most places with heavy foot traffic will still have some sort of ambient lighting (streetlights, store lights, building lights). Most of those light sources will give off extremely yellow light, which is something that your camera features should be able to mitigate. Yellow lighting is also something that you can try to correct during the editing stage. The techniques you use for night photography are the same as those you use during the day. Find the best light source possible and keep your hands steady.

Shooting someone with an umbrella can be challenging, because it will cast a shadow over their face. We had this woman angle the umbrella as far back as possible, and then lowered the "Shadows" adjustment in post-production.

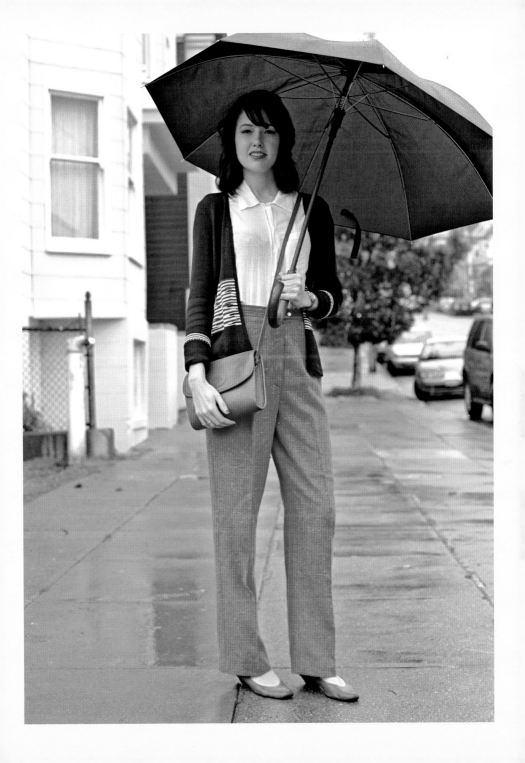

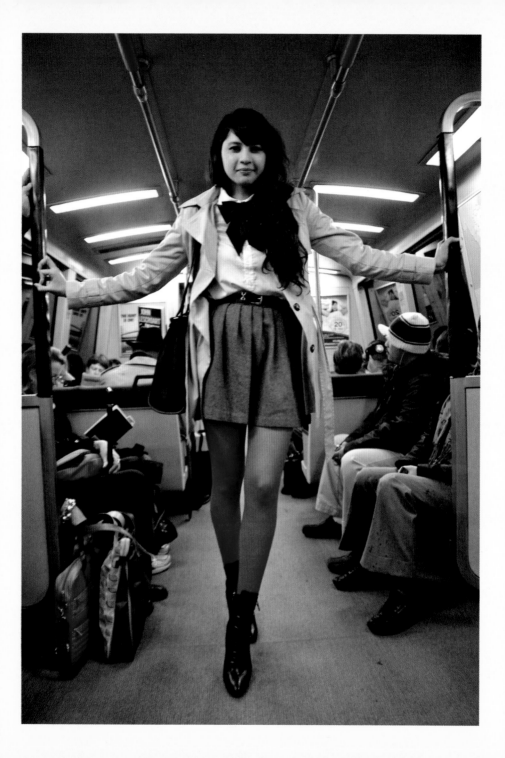

Indoors

Shooting indoors sounds like the antithesis of street style, since the very term has the word *street* in its name. That said, like shooting against a wall or during the evening, shooting indoors can add refreshing variety to your shots. This is also one way to keep shooting even when conditions outside are extremely severe (blizzard, torrential rain, zombie apocalypse, and so on).

There are two things to consider when shooting indoors, the often unnatural coloring that artificial light usually provides and the fact that most indoor public places do not allow photography. The lighting issue can be largely resolved by changing the white balance settings and further corrected during the editing process. The legality issues can really only be worked around by finding a place where taking photos is commonplace and does not raise any concerns. Shops almost always forbid photography. It's best to respect their wishes and obey the law. Always ask permission when shooting in privately owned locations. There are usually a few options where taking photos is perfectly okay:

Indoor shopping malls. Shopping malls usually do not have a problem with people taking photos within their confines—but the usual possible restrictions apply should you go inside one of the stores. There's often a lot of foot traffic, and if you're in a good mall, you might find a lot of subjects interested in fashion and thus possibly quite stylish.

Here's an example of why you must be careful of having people in the background of your shot. This photo works because all the people are looking away. If any of them had been staring at the camera, the shot would have been ruined. In fact, many shots were ruined, and this particular frame was the gem out of the batch.

L: There's something about nighttime photos that just makes them shine.

R: Here's one of our secret tricks. When shooting in low light, you can try leaning your camera directly against a wall that serves as a makeshift tripod.

L: Nighttime shots are very difficult. Find areas that are well lit with streetlights and such, and hold that camera steady. You'll be rewarded with some beautiful shots rarely seen on any street style photos.

R: This is definitely not the sharpest photo we've taken, but it shows that it is possible to take shots even at night in the rain. This particular shoot was extraordinarily difficult—one hand was used to hold the camera, and the other held an umbrella to cover the camera from potential water damage.

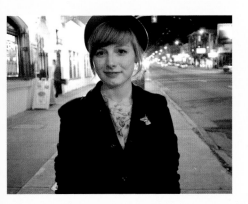
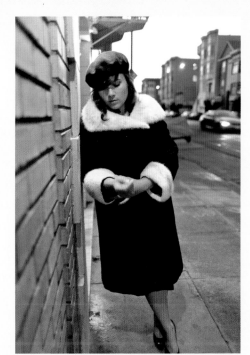
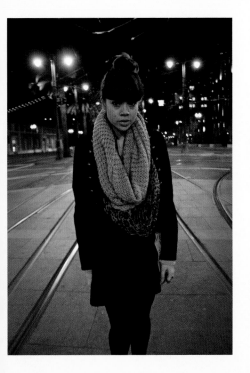
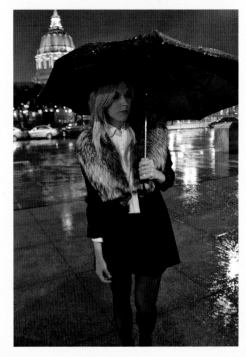

Underground Subway Stations. Unless you act suspicious and look like a terrorist, there's generally no reason why you can't stop people coming and going. There's a constant flow of traffic, providing new potential subjects every few minutes. The downside is that these places usually have dreadful lighting.

Museums and Art Galleries. Some of these institutions do not allow photography, while others allow tourists to take pictures until they're blue in the face. Do your research and go in cameras-a-blazing. We've found that modern art galleries tend to have a higher content of stylish foot traffic. (Surprise, surprise.)

Botanical Gardens/Atriums/Nurseries. There may not be a lot of stylish foot traffic, but if you're doing a planned shoot, these locations can be gorgeous settings.

Someone's home. Again, this is ideal for a planned shoot with a subject. But maybe you know someone with a cool-looking balcony that might make for a fun photoshoot?

Flattering Angles for Different Body Types

Few of us are lucky enough to be born photogenic, so as a photographer you'll want to have a few basic tricks up your sleeve to help your model find their optimal angles. Most subjects we encounter default to positioning themselves straight on to camera. For some this works beautifully, but for most of us, the angle does not translate well onto two-dimensional film. Unless you're working with professional models, don't expect your subject to instinctively know their angles or vary their poses between frames. It's up to the photographer to direct the shoot. Since you're shooting with

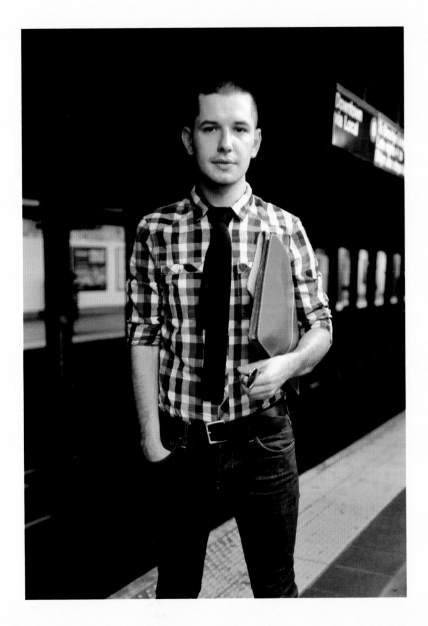

When the weather gets unpleasant, you can try scouting indoors or underground.
The artificial lighting is a challenge, but a steady hand and a lot of practice will avail you.
Make sure to adjust your camera's white balance settings when photographing in
tungsten or fluorescent lighting.

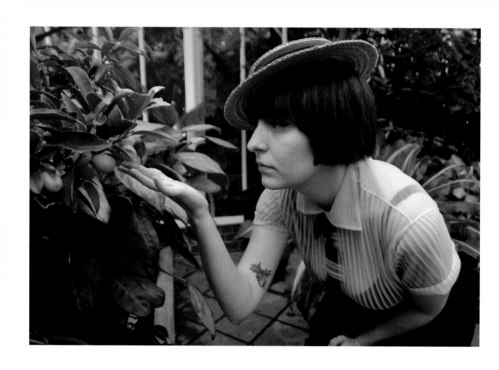

Here we were able to take advantage of San Francisco's beautiful indoor conservatory.

a digital camera, you have the added advantage of reviewing your film as you work. Each person is unique and different angles will be most flattering for their face and figure.

Don't be afraid to ask your model to turn one way or another, but bear in mind that giving them too many small directions can sometimes have the adverse effect of making them feel self-conscious and nervous.

Instead of asking them to make small movements for *you*, trying making small movements and angling the camera around *them*. The person will instinctively try to move with you as you dance around them, so make it clear that all they need to do is stand still.

If you photograph someone shorter than you, try to either bend your waist so that the camera is at their eye level or crouch down on one knee and angle the camera slightly up. This will help to elongate the figure.

STYLING YOUR SUBJECT

Many people want to view street style as a purely organic and documentary art, but as a photographer you should never be timid about taking full control of what appears in the frame. We've already covered what makes for a good background and lighting, but your directorial instincts needn't stop there. In this section, we'll talk about ways you can style your subject right on the street. "Edit" their look by asking them to remove any items that will distract from their outfit. The most frequent things that we ask people to set down are grocery bags and backpacks. But equally important are the subtle distractions such as head-phones or any bulky items the person might have in their coat or front pant pockets.

Peel back the layers of your subject's outfit by having them remove outerwear such as coats and scarves. You never know what hidden gems they might be wearing underneath.

Street Style Photo Tips

— Do take many shots rapidly on continuous shoot. You'll have more chances of getting a sharp photo since continuous shoot allows you to hold down the shutter button while the camera takes rapid-fire shots. This mitigates any shakiness from pressing the shutter button.

— Do take time to compose your shots. Take advantage of interesting or colorful backgrounds when time and space allow. Just remember that the model is the star and the background should enhance the subject and not distract. Avoid gimmicky shots like posing in front of touristy locales or busy backgrounds like statues, murals, signs, billboards, and shops. You might get a good shot if the background details are not too ostentatious, but you never want to compose a shot that will draw attention away from your subject.

— Do double-check that your camera settings are correct. Make sure it's focused correctly and that you're shooting at the highest possible resolution.

— Do take shots of groups and individuals. You can then have the option of using the group shot or each subject as an individual photo, depending on the results.

— Do try to vary your shots with close-ups and three-quarter-length shots. Just remember to try and to get that full-length shot, too. You can never have too many options.

— Do take candid shots. If you encounter your subject in an already relaxed position, such as sitting or leaning against a wall, ask them to stay just the way they are and ignore your camera. This can also work well for subjects who are walking. But bear in mind that a shot of a subject in motion requires a really fast camera and good lighting.

— Do vary people's expressions. Go with the flow and try to see what works for them. If someone tells you that they aren't comfortable smiling, don't press the issue. Some people have radiant smiles, while others look very striking with a pensive pout. Most subjects look their best if you can get a genuine reaction by making them laugh a little.

— Do remove litter and other distractions from the frame. It only takes a second to kick aside cigarette butts and other distracting objects near your subject. If you can't move or angle the distraction out of the shot, trying moving your subject to a different location. You can always edit things out post-production, but you still want to minimize the amount of editing needed.

— Do ask your subject to take off or set aside anything that you don't want to appear in the photo. Whether it's a shopping bag or a superfluous accessory, an extraneous item will distract from the focus on the outfit. Have them put the items down in a safe nearby spot.

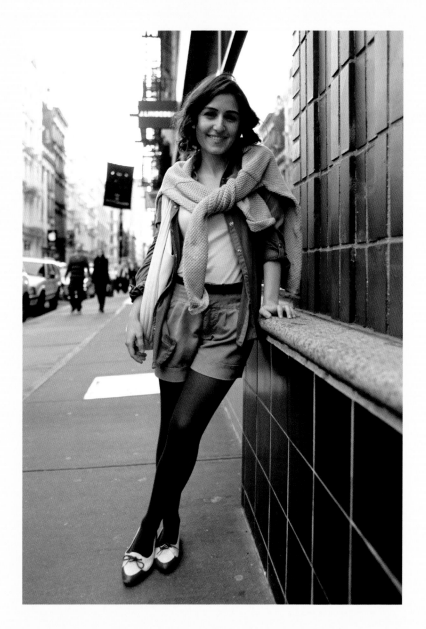

It's not noticeable, but this photo was taken from a kneeling position because the subject is so petite. The leaning pose against the wall also helps lengthen her and directs focus to her pretty smile—since the lines of the wall and buildings across the street all form an X leading to her center. It draws the viewer's eyes in.

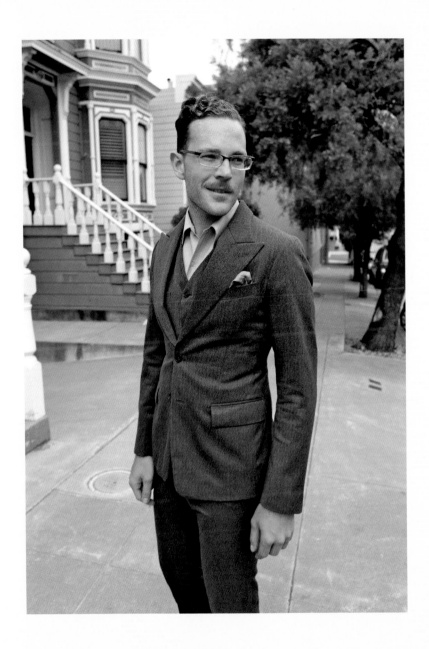

We photographed this gentleman from a slight angle to better show the slim cut of the suit.

L : We try to let our subjects be themselves when they pose. Some of them have shy, demure poses, and that's okay.

R : Some people might be very gleeful and smiling when you photograph them, some may be more pensive. Try to let them be themselves, because if they're uncomfortable, it usually comes across in the shot. A serious expression can still be excellent for your photo if it's genuine.

L : This man is of average height, so we shot him from about eye level. Kneeling down helps to elongate shorter subjects. If you yourself are tall or you have something to stand on or a steady enough hand, you might want to experiment with shooting by holding the camera above your head. You get a higher perspective, which shortens subjects. (You rarely want to do this. Those higher angles are better suited to event photos.)

R : This is an ideal pose for many body types. It was such a pleasure working with this subject because she instinctively understood her body and felt very comfortable in front of the camera.

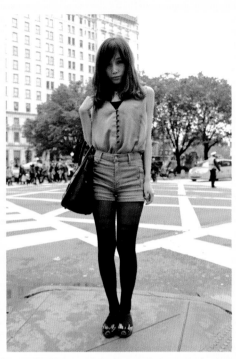

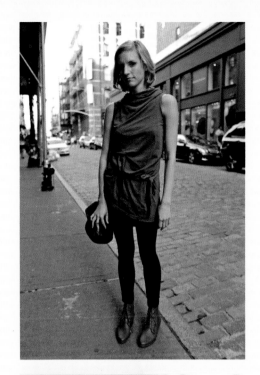

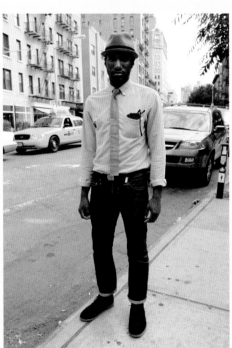

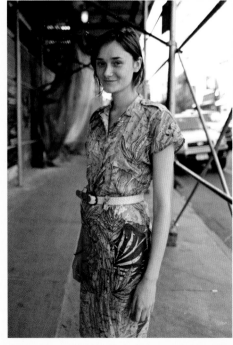

Here's one of our favorite sitting down shots. Remember, we use the same rule when shooting shoes, bags, or anything else that is at a lower level: Crouch down to the level of your subject and try to avoid shooting looking down. There will rarely be a time you want to do that.

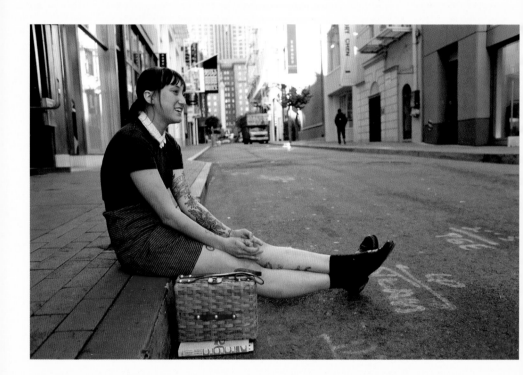

Again, vary your angle to showcase something great, like an amazing hairstyle. Having your subject sit down is also a nice change of pace and a good way to help someone who is nervous and having a hard time posing without feeling awkward. (This particular subject was not nervous. We just had her sit down so we could use the lines of the railing in the shot.)

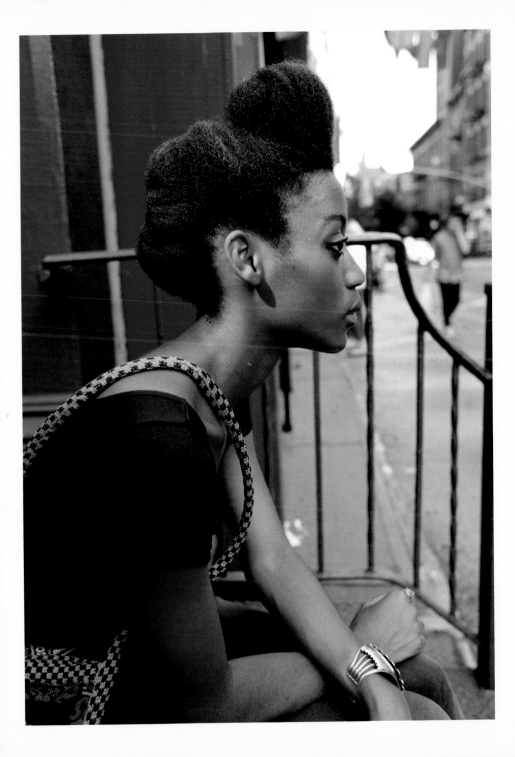

One pet peeve we have is when people stand with their legs too close together, touching. It makes their legs form one block, and you lose the definition and silhouette of their body and outfit. We usually have our subject stand like this young lady, who is demonstrating a well-done basic pose. Remember that many of the people you encounter are not professional models, so try to learn basic poses to suggest for them. If you notice that your subject is unsure how to pose, jump in with a few gentle suggestions.

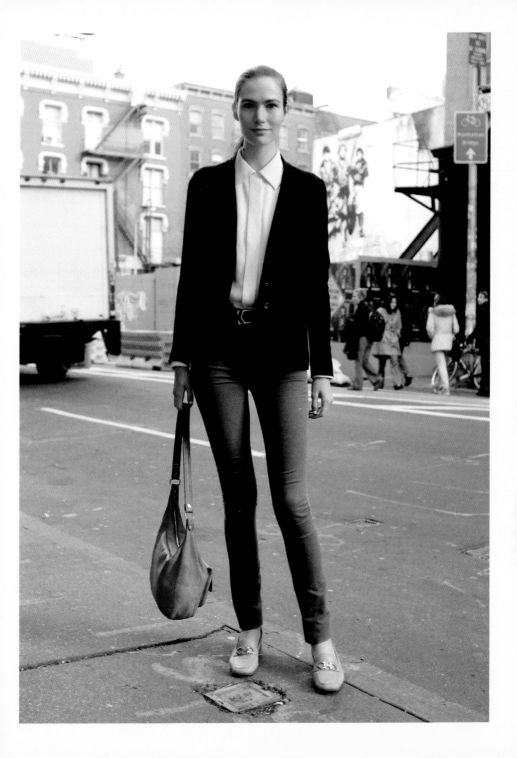

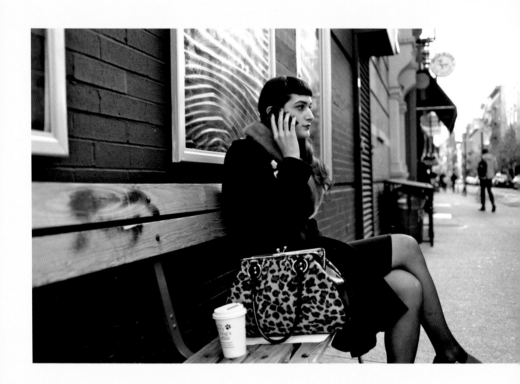

Subjects often provide the best serene candid shots when they're just going about their business, taking a phone call on a coffee break, for example. This image is also a good example of composition—note that the lines of the bench and brick wall converge toward the subject. The background gives a sense of depth and location, while still allowing the subject to be the main focus.

L: We encountered this subject sitting just like this, and it looked perfect, so we took the shot as it was. The challenge was the people directly behind the glass inside the coffee shop. Fortunately, the glare on the glass obscured them enough to keep the focus on the striking fellow. Remember: When your subject is seated, make sure to crouch down on one knee to photograph them at their level.

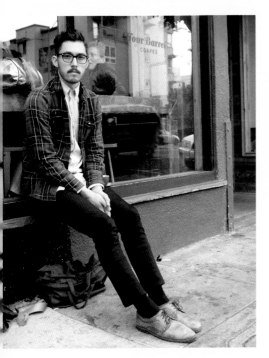 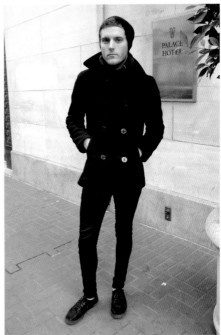

R: Some people might put their hands in their pockets, while others might put their hands on their hips or stand perfectly still. Ask your subject to try different stances, but always let them pose naturally on their own first.

— Don't take all of your photos from one position. You don't want to come back to the editing room with ten of the same photo and no variety. Vary the angles you shoot from—the more the better. Shoot high, shoot low while kneeling, move left and right. You'll get various lighting results and have more options in case your subject is blinking or blurry.

— Don't shoot your subject too close up or too far away. You'll want room to crop the photo if it is off center, but you also don't want to be so far away the photo's resolution suffers because you have to crop down and zoom in. As a general rule, the subject should fill about two-thirds of the frame.

— Don't publish photos of people with unflattering expressions. This might be chewing gum or talking during the photo, squinting from the sun or wind, or just feeling or looking awkward at the time of the shot. Try to get the subject to relax.

Here's the San Francisco rendition of wide-leg jeans. We almost didn't approach this woman because she was wearing a big jacket that obscured most of her outfit. But we had a feeling that something wonderful was hiding underneath and decided to go with our gut. To this day it is one of our favorite San Francisco photos. It just goes to show how important it is to peel back the layers on someone's ensemble. You never know what you might uncover.

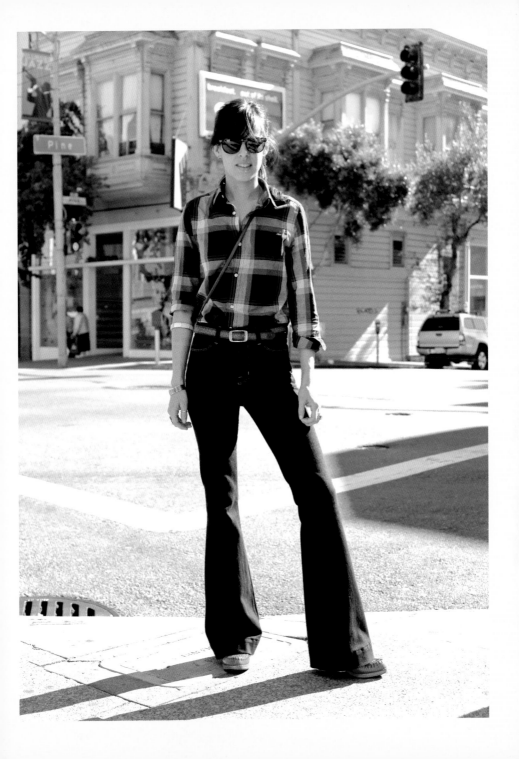

L: This subject had an adorable scarf on originally, but we choose this shot of her so that you can see more of her jacket and sunglasses.

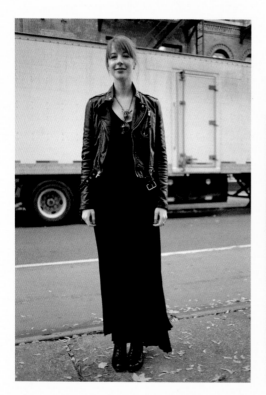 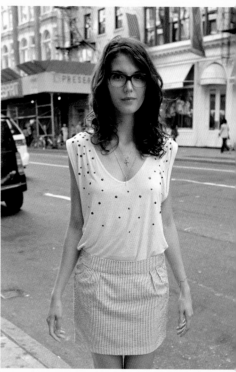

R: You will be surprised how comfortable many people are when they agree to be photographed. Don't be too shy to ask if you can style them, if you feel you can make the shot better. We moved this girl's hair from behind her shoulders to lay in front, since those wavy locks are a beautiful detail of her personal style. It is usually the small changes that create the most impact.

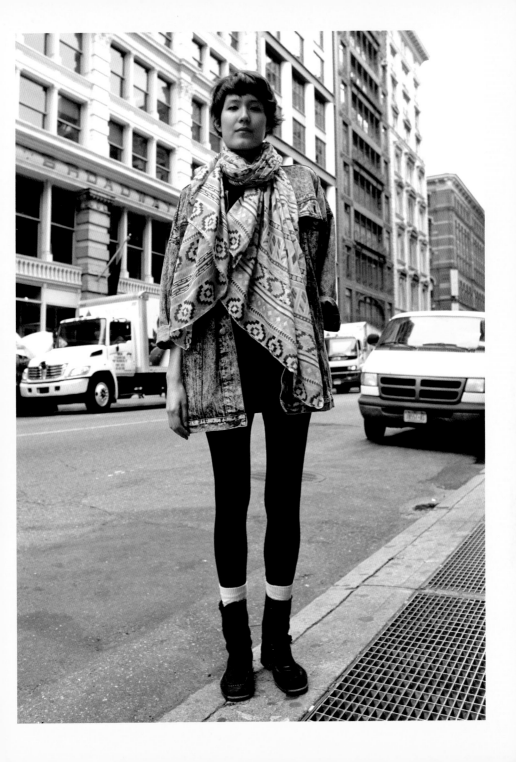

— Don't take photographs of shoes and bags at your eye level. That is to say, crouch down to the level of the item and take the photo. Kneel, or put your camera low to the ground. You will end up with a superior photo because of the interesting background, sharp detail, and good angle on the subject—which in this case is the shoe or accessory you are focusing on.

— Don't forget to angle passersby out of your shot. This is the worst kind of distraction. You can mitigate this problem if the people are far enough in the background or your camera and lens setup provides a lot of bokeh.

— Don't place a subject with a light-colored outfit and/or hair against a light background, and likewise, don't place a dark outfit against a dark background. The outfit and subject's details will be lost. This sounds obvious, but when you shoot in a hurry you might forget. This is especially true for platinum blonds against a white background. Their hair will be hard to see and they might appear bald or washed out at first glance.

— Don't forget to adjust your subject's minor details. Be their mirror. Help them fix pocket flaps and collars that are askew; laces, buttons and zippers that are undone; or bags and accessories that are not angled to face the camera.

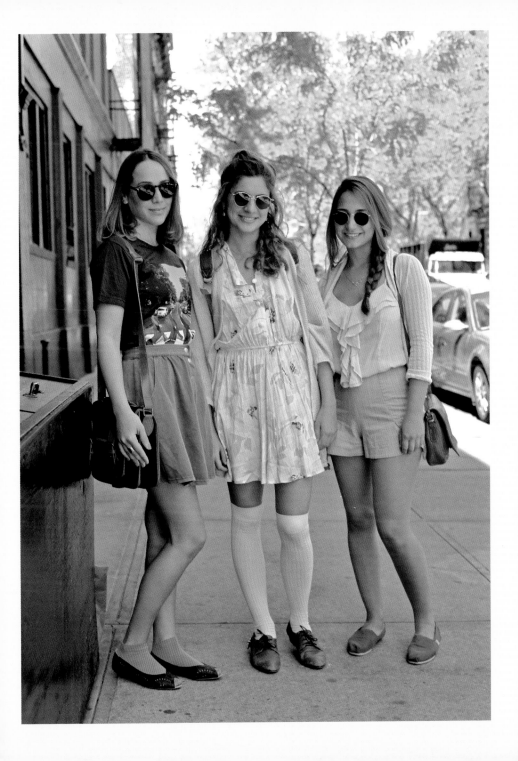

MODEL RELEASE

In consideration of my engagement as a model, upon the terms herewith stated, I hereby give to

[photographer] his/her heirs, legal representatives and assigns, those for whom the photographer is acting, and those acting with his/her authority and permission:

a) the unrestricted right and permission to copyright and use, re-use, publish, and republish photographic portraits or pictures of me or in which I may be included intact or in part, composite or distorted in character or form, without restriction as to changes or transformations in conjunction with my own or a fictitious name, or reproduction hereof in color or otherwise, made through any and all media now or hereafter known for illustration, art, promotion, advertising, trade, or any other purpose whatsoever.

b) I also permit the use of any printed material in connection therewith.

c) I hereby relinquish any right that I may have to examine or approve the completed product or products or the advertising copy or printed matter that may be used in conjunction therewith or the use to which it may be applied.

d) I hereby release, discharge and agree to save harmless [photographer], his/her heirs, legal representatives or assigns, and all persons functioning under his/her permission or authority, or those for whom he/she is functioning, from any liability by virtue of any blurring, distortion, alteration, optical illusion, or use in composite form whether intentional or otherwise, that may occur or be produced in the taking of said picture or in any subsequent processing thereof, as well as any publication thereof, including without limitation any claims for libel or invasion of privacy.

e) I hereby affirm that I am over the age of majority and have the right to contract in my own name. I have read the above authorization, release and agreement, prior to its execution; I fully understand the contents thereof. This agreement shall be binding upon me and my heirs, legal representatives and assigns.

PRINT NAME

SIGNED

DATED

ADDRESS

CITY

STATE / ZIP

PHONE

E-MAIL

RESOURCES AND SUPPORTS

MODEL RELEASES

A model release is a contract that says a model is allowing a photographer the rights granted in the document, usually pertaining to the sale and publishing of the images for commercial use.

Many adults have no problem publishing photos taken in public or any public place where one does not have a reasonable expectation of privacy (bathrooms and fitting rooms are examples of places that are out of bounds). This is how paparazzi make their living. As a street style photographer, you can make a choice about where to draw the line. We recommend that you take the professional approach and ask permission when photographing a subject and get a model release signed if possible. Respect people when they ask to not have their photos commercially sold or reproduced. (Models for instance, often cannot sign model releases without their agents' or companies' permission.)

Often the best photos are candid, and some of the most well-known street style bloggers take candid photos. This is a fine line to walk, so do try to get permission and have a release signed, and if the subject clearly is camera shy or hostile, cease shooting and apologize. Don't forget, if photographing a minor, you'll want to get their guardian's permission first.

L: A sample model release.

BLOGGING

Now that you've started taking great street style photos, you probably want to do something with them, like posting them on a blog of your own. In this section, we'll cover the fundamentals you should know about creating and maintaining a street style blog.

Copyright Law

Copyright law for websites states that the instant original content is published on a website, it is considered copyrighted and the intellectual property of the creator. That said, it is a good idea to have a copyright footnote somewhere on your site to remind potential plagiarists and content thieves of this.

Here is a basic example copyright footer:

Copyright © Your blog name here. All rights reserved.

Different Types of Street Style Blogs

Before you embark on the journey of creating your own blog or portfolio, you might ask yourself what kind of street style photographer you want to be.

Regional. Focused on covering street style in a specific area. This is usually the way one starts out, since it can be a very costly and time-consuming endeavor for a beginning street style blogger to try to cover more area than a single city.

success to cover street style all over the world on a regular basis, give yourself a big pat on the back and keep up the good work!

High fashion. This usually goes hand-in-hand with a blog covering one or more cities that are major fashion centers: New York, Paris, Milan, and so on. Bloggers following high fashion usually have to look for fashion models on the street and attend or camp out in front of high fashion events.

Documentary. This is a mixture of fashion and documenting/cultural-anthropology. This sort of blog photographs all sorts of subjects, not really searching for quality in fashion, but rather documenting everything from everyday looks to outlandish costumes on Halloween.

Niche. Of course, there are always blogs that cover very specific subjects, styles, and aesthetics exclusively. These might include men, children, seniors, ethnicities, accessories, or sub-cultures (such as goth or hip-hop.)

HTML Coding

When it comes time to design your website and post the results of your labors, you might need a little HTML knowledge. Most blogging platforms are about as easy to use as Facebook, but knowing some basic html codes will help you compose your photos and text into more specific parameters. Don't be scared! It's not as hard as it sounds, and there are plenty of websites and books available to help you.

When you use your blogging platform, be it Blogger/Blogspot,

wordpress, tumblr, or any other alternative, you usually have an option to edit the actual html that composes your posts. There will be a tab or button that allows you to see it, listed as "HTML." (Convenient, isn't it?)

Once you click on the button, you can fiddle with html as necessary. It can be daunting, and editing it incorrectly could mess up how things look, so you should copy and paste the original code somewhere so that you can reinstate it in the event something does go wrong.

Basic HTML Codes:

There are, of course, many codes to learn. We will give you the ones that are most commonly used and most useful for a street style photographer/blogger. Learn these, and then expand your knowledge as needed.

`` This is the most basic and common code you will be using. It will post your image, and all you need to do is copy and paste the URL of your image where the parentheses are. Easy peezy. IMG stands for image, and SRC stands for source.

`` You can add to the code to resize the image for the post. Just add the corresponding pixel numbers in the width and height sections. You don't have to do both width and height; if you leave out one or the other, it will keep things proportionate for you, so if you put a width of 500, it will give it the appropriate height to retain the image's original dimensions.

`(Insert text here)` This code makes all text within it **bold**.

`<i>(Insert text here)</i>` This code makes all text within it *italicized*.

`<u>(Insert text here)</u>` This code makes all text within it <u>underlined</u>.

\<h1>(Insert text here)\</h1> This code makes all text within a headline, bolding and enlarging it greatly. You can use h1 or h6, and all the numbers between, with h1 being the largest and h6 being the smallest.

\<p> This creates a paragraph break.

**\
** This creates a line break.

\<hr/> This will create a horizontal line.

\(Link-text goes here)\ This will make a section of text into a clickable link.

\(Link-text goes here)\ By adding the extra bit about "target blank," you cause your link to open as a new window when someone clicks it. This is very useful, since you probably want people to stay on your blog/website as long as possible.

\\\ This turns an image into a clickable link. The height and width parameters, as well as the target blank one, can also be used as you typically would.

Photo Hosting Sites

Flickr is the site we use for theSFStyle.com, and it's been good to us. The cost is extremely low, and the reliability is solid. There are many options, however, and Wikipedia has a very comprehensive, informative, and unbiased list with information about fees and storage space: http://en.wikipedia.org/wiki/List_of_photo_sharing_websites

Blogging Tips

—Do set up a unique URL. It is negligible in cost, and usually really easy to set up when you start your blog on Wordpress or Blogger.

—Don't have a longwinded title for your blog. It is not conducive to people remembering your name. Try to be unique, but also bear in mind searchability and keywords. Try to come up with a URL that has some correlation to your blog's name.

—Do have a cool and easy-to-read banner or title logo for your blog.

—Don't use fancy or obscure fonts and hard-to-read colors. You want your text to be uniform across as many browsers and devices as possible. There's a reason that Arial, Helvetica, Times New Roman, and Verdana are standard.

—Do not have your photos grouped together and displayed too large or small. It lessens the impact, divides the viewer's attention, and looks unprofessional. We recommend a width of 600 to 800 pixels.

—Do have between four and seven posts displayed per page. Having only one post can be very annoying for a visitor to have to click through, while having too many can make your blog load slowly.

—Do make it easy for readers to engage with your content by having "like" and "share" buttons for each post.

—Do monitor commentary on your website. If you choose to leave it open for the public to post as they please, you might get the occasional hateful comment (known also as "trolling"). More often, you will get bots/automated programs leaving spam links to other sites.

—Do start simple. Do have all your social media (Facebook, Tumblr, Twitter, and so on) as easy to see and click buttons. But don't go overboard. It's okay to have a lot of necessary banners and links, but they should be as organized and uniform as possible. You don't want anything to distract too much from the images that you've worked so hard to procure.

—Don't have music, busy background or wallpaper, and gaudy animated flash images and effects. These distractions have no business on a professional website.

—Do use text that helps bring up your blog more often on search engines. If SEO (search engine optimization) is important to you, use keywords in your text content when possible. But don't shoehorn in terms that don't relate. Your site needs to make sense and not look forced and obvious.

—Don't plagiarize images and content. Always ask permission whenever possible and provide links back to the source. You wouldn't want someone stealing your work, so be respectful.

—Don't post anything you're not proud of. Less content is better than bad content. Blurry and unflattering images will lower a new visitor's opinion of your blog. That said, you've got to work hard to be able to provide high-quality content regularly.

—Do OPTIMIZE your images. Don't let your blog load slowly or, worse, not at all. Since street style and fashion blogs are image heavy, it's very important for your images to be as high quality as possible while still being small files. You want people who are using smartphones or slow Internet connections to be able to load your site.

—Do make sure all your links work. Not only are bad links annoying to your readers, but Web rankers like Google PageRank take into account how many dead/broken links a site has and lower the site's score.

—Some platforms and blogs have the option of having your content load continuously, so the visitor can just keep scrolling down the page rather than clicking a link to read older posts. This is not inherently bad, but bear in mind that if you do not have some sort of archive link to get to older posts, then your viewer has to do a lot of scrolling to reach your older content that is buried a long way down.

—Foul language and explicit content of any sort is not recommended unless that's the specific angle you're trying to play to. Anything that limits how many people can come to your site will limit your growth. A lot of people read blogs at work—so even if they don't mind curse words or nudity, they might not come as often to your blog if it contains NSFW (not safe for work) content.

—When you get to that point of growth, don't be afraid to brag a little. Have a clean and organized press page with links to your published works.

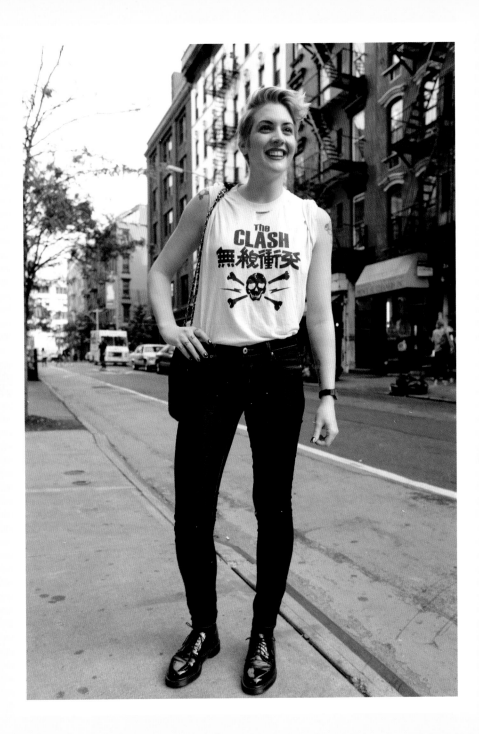